IMAGES
of Rail

San Francisco's
Market Street
Railway

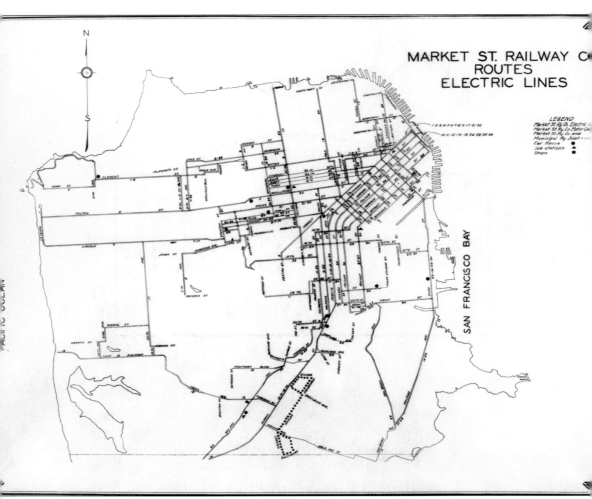

This map shows Market Street Railway lines, c. 1925 (Courtesy Richard Schlaich collection.)

ON THE COVER: Third Street is two-way in this November 10, 1936 photograph, and we can see three cars showing off their white fronts. The San Francisco Examiner Building at Market Street announces the release of a souvenir edition upon the opening of the Bay Bridge. (Courtesy Department of Public Works City Engineer's Office San Francisco Municipal Railway Photography Department, Richard Schlaich.)

IMAGES
of Rail

SAN FRANCISCO'S
MARKET STREET
RAILWAY

Walt Vielbaum, Philip Hoffman,
Grant Ute, and Robert Townley

ARCADIA

Published by Arcadia Publishing
Charleston SC, Chicago IL, Portsmouth NH, San Francisco CA

Printed in Great Britain

Library of Congress Catalog Card Number: 2004118157

For all general information contact Arcadia Publishing at:
Telephone 843-853-2070
Fax 843-853-0044
E-mail sales@arcadiapublishing.com
For customer service and orders:
Toll-Free 1-888-313-2665

Visit us on the internet at http://www.arcadiapublishing.com

Schedule of Line Closures

The page number listed in the right hand column of each route refers to the first page on which a photo of that route appears.

No.	Line	Closure	Page	No.	Line	Closure	Page
1	Sutter and California Streets	7/2/49	10	27	Bryant Street	8/13/48	85
2	Sutter and Clement Streets	7/2/49	13	28	Harrison Street	4/1/40	110
3	Sutter and Jackson Streets	7/2/49	13	29	Kearny and Broadway	5/10/41	111
4	Sutter and Sacramento Streets	7/31/48	22	30	Army Street	6/30/40	100
5	McAllister Street	6/5/48	23	31	Balboa Street	7/2/49	43
6	Haight and Masonic Avenue	7/3/48	28	32	Hayes and Oak Streets	5/14/32	
7	Haight and Ocean	7/3/48	31	33	Eighteenth and Park	10/5/35	86
8	Market and Castro Streets	7/1/49	50	34	Sixth and Sansome Streets	4/4/36	112
9	Valencia Street	1/15/49	52	35	Howard Street	1/27/40	74
10	Sunnyside	4/1/42	56	36	Folsom Street	1/28/40	77
11	Mission and Twenty-fourth Streets	1/15/49	58	40	San Mateo Interurban	1/15/49	62
12	Ingleside and Ocean	10/31/45	62	41	Second and Market Streets	1/15/49	113
14	Mission Street	1/15/49	66	42	First and Fifth Streets	5/10/41	113
15	Kearny and North Beach	5/10/41	106	43	Broadway and S.P. Depot	5/9/41	114
16	Third and Kearny Streets	5/10/41	107		Bosworth Street	11/14/28	
17	Haight and Ingleside	12/22/45	37		Parkside		
18	Daly City and Cemeteries	1/15/35	80		Post and Leavenworth Streets	1934	98
19	Ninth, Polk, and Larkin Streets	6/25/39	90		Visitacion Valley	7/31/37	101
20	Ellis and O'Farrell Streets	9/27/47	80		Pacific Ave Cable	11/27/29	104
21	Hayes Street	6/5/48	40		Castro Street Cable	4/5/41	103
22	Fillmore Street	7/31/48	93		Sacramento Clay Cable	2/14/42	47
23	Fillmore and Valencia Streets	6/15/35	97		Powell Mason Cable	N/A	114
24	Mission and Richmond	6/15/35	97		Washington Jackson Cable	N/A	87
25	San Bruno Avenue	7/31/48	82		Fillmore Hill Counterbalance	4/5/41	95
26	Guerrero Street	1/14/39	73		South San Francisco	12/31/38	78

The names (and/or route numbers) of some of these routes changed through the years. The date shown is the last day of service as a full-time route. During World War II, a number of routes were partially reestablished (e.g.: No. 16, Third and Kearny; No. 19, Polk and Larkin; No. 26, San Jose Avenue; No. 30, Army Street; No. 36, Folsom Street).

Schedule of Car House Closures

Car House	Date	Car House	Date
Pacific Ave Cable	11/27/29	Haight	12/9/46
29th and Mission	1/15/35	McAllister	7/3/48
Oak and Broderick	8/15/38	Turk and Fillmore	7/31/48
28th Valencia	1/14/39	Sutro	1/20/51
24th and Utah	1940	Funston Ave Yard	1949
Castro Cable	4/5/41	Geneva Ave	N/A
Kentucky	5/11/41		

—Philip Hoffman

CONTENTS

ACKNOWLEDGMENTS

Whenever possible, all photos are credited to the original photographer and collection. We regret any oversights in crediting actual photographers. We relied heavily on the collection of authors Walt Vielbaum and Philip Hoffman as well as that of the late Richard Schlaich. Many photos are of MSR equipment after the 1944 Muni merger. We would like to thank both Emiliano Echeverria and Walter Rice for their assistance in summarizing the company history.

The authors are grateful to the not-for-profit Market Street Railway for its encouragement in the development of this book. The authors' proceeds from its sale are being donated to the MSR's ongoing preservation and restoration work on the cars operating on San Francisco's historic streetcar fleet. Should you wish to support these efforts, contact the Market Street Railway at 870 Market Street, Suite 803, San Francisco, California 94102 or at www.streetcars.org.

Dedicated to two groups of men and women: the employees of the Market Street Railway Company (1921–1944), who moved San Franciscans to and from their homes in safety and comfort, and the volunteers of the not-for-profit Market Street Railway (1976 to date), the preservation group that honors the memory of the former company.

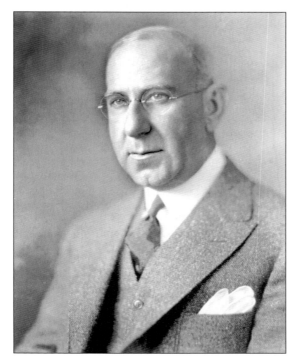

In December of 1925, the Byllesby Company installed Samuel Kahn as executive vice president of the Market Street Railway. This event signaled the beginning of a new way of doing business. Samuel Kahn (1882–1953) was the company's driving force over the next two decades and he turned around the image of the company. Eventually, in 1938 he became one of the principal owners of the company until its purchase by the City in 1944. (Courtesy Boyé Studios photograph, Richard Schlaich.)

INTRODUCTION

Founded by Spanish explorers, put on the map by gold-seeking "Forty-niners," and developed into the "Paris of the Pacific" by the Comstock Strike silver barons, San Francisco was almost entirely destroyed in a disastrous earthquake and fire on April 18, 1906. Like its mythological symbol, the phoenix, the city rose from its ashes and rebuilt itself into a modern metropolis. Upon the opening of the Panama Canal, it celebrated its rebirth by hosting the Panama-Pacific Exhibition in 1915.

San Francisco entered the Jazz Age stylish, proud, and confident. With its business center and port the economic engines of the Pacific Coast, San Francisco focused on developing its largely unpopulated outer lands. The street railway systems—primarily the city-owned Municipal Railway and the privately held Market Street Railway—were the key forces shaping that growth.

The Market Street Railway Company could trace its history back to July 4, 1860, when the San Francisco Market Street Railroad began operating a steam railway from Third and Market to Sixteenth and Valencia Streets. Later converted to horse car operation, this company was subsequently acquired by the San Francisco & San Jose Railroad and renamed the Market Street Railway in the late 1860s. Later it was purchased by the Southern Pacific Railroad (SP), seeking a foothold in street railway operations in San Francisco.

Subsequently, in 1882 Southern Pacific renamed the company Market Street Cable Railway, reflecting the soon-to-be dominant mode of power. This was consolidated with several other horse and cable operations into the Market Street Railway in 1893.

This company's assets were purchased in 1902 by the Baltimore Syndicate, which merged them with the Sutter Street Railway and the San Francisco & San Mateo Electric Railway under the name United Railroads of San Francisco (URR). The Market Street Railway retained a financial holding in the new company.

Through its early history, the URR was involved in much of the graft and corruption that plagued San Francisco government in the period. Heavily in debt in 1921, the bankrupt URRs lines transferred back to the Market Street Railway, which reemerged once again as an operating railway.

Later, it was acquired by the Standard Gas & Power Company, which hired the Byllesby Corporation, an Eastern public utility management company, to operate the property in November 1925. The next month, Byllesby brought in Samuel Kahn as executive vice president.

This event signaled the beginning of a new way of doing business. Kahn was the company's driving force over the next two decades, and he immediately began to turn around the image of the company. He modernized the plant and instilled employees with a public relations code that stressed Byllesby's philosophy of public utility operation. Byllesby purchased the property outright in the late 1920s but had to divest it in 1938 due to regulatory limitations on public utilities holdings. At that point, Samuel Kahn and some associates purchased the company.

They operated the railway until a city bond issue authorized its purchase for $7.2 million with the consolidation occurring on the morning of September 29, 1944. Between 1945 and 1949, all Market Street Railway streetcar lines were replaced with motor or trolley coaches under Muni's modernization program.

This is the story of the operation of the Market Street Railway spanning the Roaring Twenties, the Great Depression, and ending with the boom times of World War II. Nationally, it was a time that street railways were challenged by the emergence of the automobile, cheaper

and more flexible motor coaches, and notably the "nickel jitney"—taxi-like competing cars that prowled their routes.

During this time, the company struggled to keep an aging fleet in service for the people of San Francisco despite shortages of materials and workers and increased demand for service. Perhaps its greatest challenge was the unfavorable regulatory environment from the city that operated the competing Municipal Railway.

The Market Street Railway offered its riders free transfers over its citywide system. These colorful transfers grouped lines into "families" by general area served and direction of travel. This book is organized into chapters by these routes using examples from the 1933–1937 series as chapter headings.

The final chapter is introduced by Sunday and holiday passes and provides an overview tour of some innovations, events, and accomplishments of Kahn and the Market Street Railway team during this era. It will also show the fate of some of the cars and some successful restoration accomplishments.

We hope you enjoy your tour of San Francisco in the 1920s, 1930s, and 1940s aboard San Francisco streetcars during their heyday. So climb aboard . . . be sure to ask for a transfer . . . step forward please and hold on . . . two bells to the motorman. We are underway!

The Byllesby Code.

"Deal honestly, fairly and lawfully with all concerned. Make your business and personal conduct above reproach.

"Your business will be most profitable if you charge the lowest possible rates and develop the largest volume of service.

"Try to set a high business standard. Keep the cards on the table. We want no secret deals, no favoritism, no corruption. Sooner or later the people will understand. This course may cause you harder work for a time, but eventually it will make it easier.

"Never forget that your company is a public servant that wants no dollar that it does not fairly earn.

"Take the people into your confidence. Give them the facts.

"Treat your customers as human beings, realizing that mutual good faith and tolerance form the basis for successful commerce between man and man.

"Participate in the public and semi-public welfare activities of your city.

"Maintain the old-fashioned virtues. They will always win in the long run. We are back of you to the last dollar as long as you do your honest best, but we will not forgive any act that is not clean and honorable."

The Market Street Railway was the successor to the United Railroads, which, due to poor service, abysmal history of labor relations, and role in San Francisco graft and corruption, was well-hated by both the city's people and political leadership. When the Byllesby Corporation took over management of the MSR, it installed a new management philosophy—embodied in the Byllesby Code. Were the URR under Byllesby management early in the century, maybe there would have been no impetus to establish the city's own municipal railway. (Courtesy Richard Schlaich collection.)

One

NORTH OF MARKET LINES

Line 1) Sutter–California
Line 2) Sutter–Clement
Line 3) Sutter–Jackson
Line 4) Eddy–Richmond
Line 5) McAllister
Line 6) Haight–Masonic
Line 7) Haight–Ocean
Line 17) Haight–Ingleside
Line 21) Hayes
Line 31) Balboa
Sacramento–Clay Cable

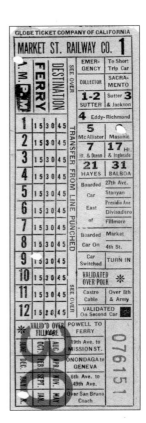

This group of lines included some of Market Street Railway's busiest. They all ran on Market Street (even the Sacramento Cable for 50 feet). From Andrew Halladie's 1873 six-block Clay Street Hill Cable line grew the Sacramento–Clay Line, which by 1893 stretched from the ferry to Sixth and Fulton Streets—San Francisco's longest cable line. Cut back to Fillmore Street in 1906, it closed in 1942. MSR's heaviest car line, No. 5, ran from Market out McAllister, cut through its car barn and ran straight out Fulton to Playland-at-the-Beach. Another moneymaker, No. 7, turned off Market at Haight, ran out Lincoln Way past Poly High and Kezar Stadium, and then through Golden Gate Park (the only car line to do so). It ended at the Playland Loop. Route adjustments in 1935 changed the No. 4 line (Eddy-Richmond) to a fourth Sutter line, called Sutter–Sacramento. MSR's newest car line, the No. 31 opened in 1932. Equipped with the Balboa hi-speeds (which could outrun a Presidents' Conference Car), it immediately gave Muni's "B" line competition. The competition would have been greater had not the City insisted that the No. 31 end at Thirtieth Avenue. Shortly after 6:30 p.m. on July 2, 1949, No. 2 car 230 turned off Market Street for the last time. This was also the last usage of the outer set of Market Street's unique four tracks. After 36 years, the "Roar of the Four" was silent.

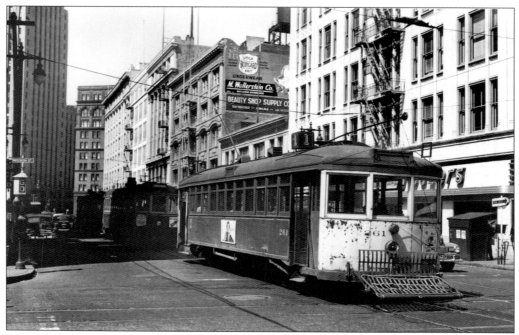

Pictured here is First and Mission in spring 1949 with a "bird cage" signal and Foster's Restaurant. The No. 1 has only a month left. First and Fremont were the only two streets in San Francisco with double tracks in the same direction. (Courtesy Walter Vielbaum.)

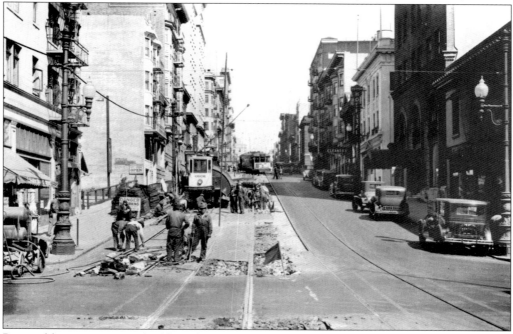

Pictured here are crews rebuilding the tracks at Sutter and Larkin in 1930. Differential Dump car 0931 is parked curbside while an outbound car is negotiating a "shoo fly" up the hill. Vintage automobiles line the street by Sutter Hospital. (Courtesy MSR/Muni.)

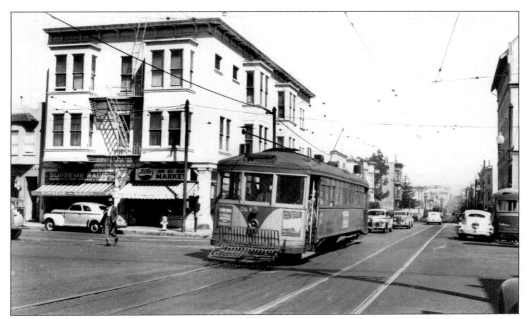

Crossing Divisadero on Sutter with its "V" front part scheme is No. 1 car 264. The Supreme Radio and S&S Market have been replaced with an addition to Mt. Zion Hospital. An ex-MSR bus painted in Muni blue and gold enters the scene on the right (Courtesy Philip Hoffman.)

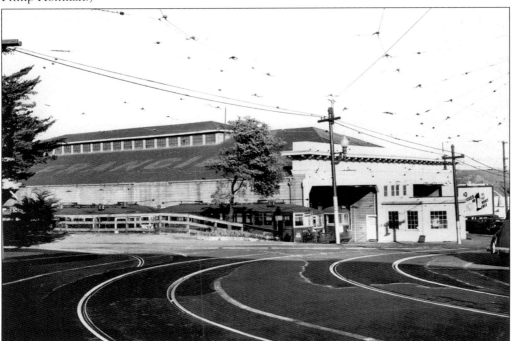

The Sutro Barn at Thirty-third and Clement was originally built by Adolph Sutro in 1896 for his pioneer electric line that eventually became the No. 2 line. Among visible tracks in this 1949 view are cars of the No. 31, D, C, and No. 2 lines. (Courtesy Gerald D. Graham.)

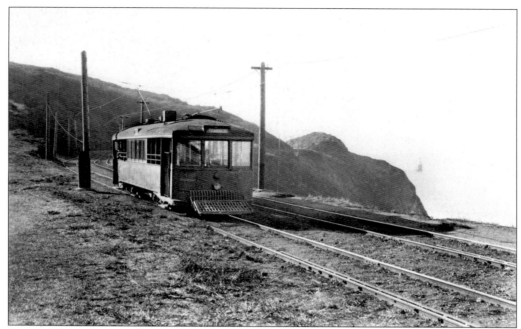

Originally a steam line, the scenic cliff line became electric in 1905. Throughout the first two decades of the 1900s, the cliff line was a must on any visitor's list. Mile Rock Lighthouse lies offshore. (Courtesy MSR/Muni.)

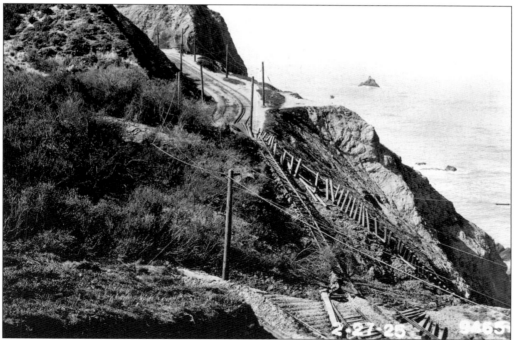

You don't fool with Mother Nature. Heavy rains in 1925 destroyed the scenic line. A replacement road also slid into the ocean in the 1940s. A trail now occupies the area. (Courtesy John G. Graham collection.)

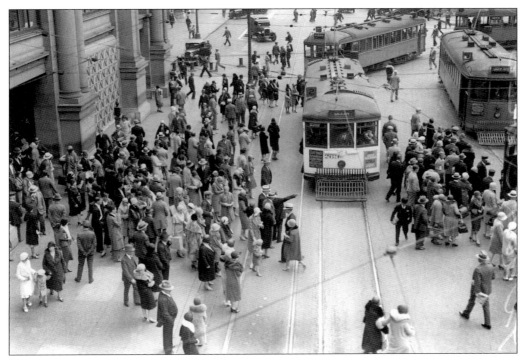

It was a quiet afternoon at the ferry loop in 1930. At this time, however, 21 different lines squealed around the loop with a new car arriving every few seconds. The curbside track was used by the State Belt Railroad that covered all the Embarcadero. (Courtesy Richard Schlaich.)

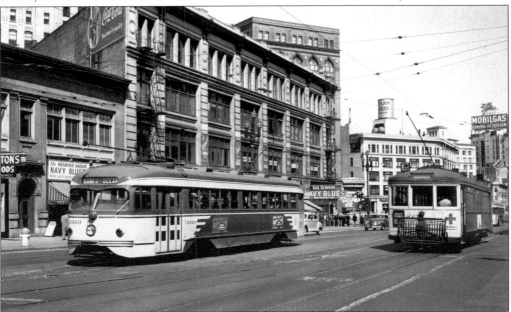

A brand new Presidents' Conference Car (PCC) 1010 glides up Market at Battery in 1948. The Tilden Sales Building, Navy Blue stores, Mobil Gas sign, and outer tracks are all gone, but car 1010 is a regular car today on the "F" line. (Courtesy Walter Vielbaum.)

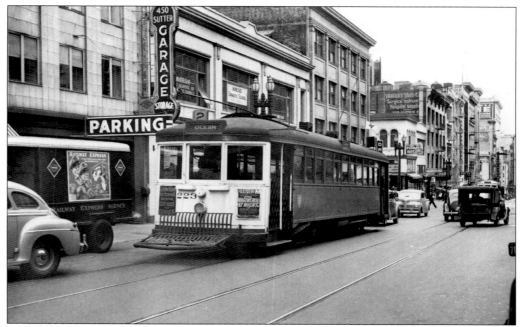

This 1941 view of No. 2 car 223 shows it in front of the 450 Building. The Sutter-Stockton garage now occupies the site of the Pink Rat lunchroom. (Courtesy Al Thoman.)

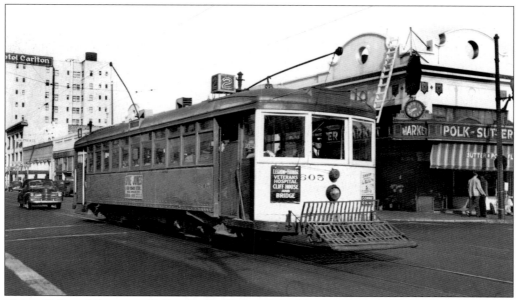

This is Polk and Sutter in 1949 with the Carlton Hotel in the distance. Car 605 was MSR 205. When the Muni merged with the MSR in 1944, it had cars numbered in the 200s. To avoid confusion it renumbered MSR 200s in the 600 series. Car retirements ended this problem in 1948. (Courtesy Philip Hoffman.)

My Dream Is Yours with Doris Day is playing at the Uptown Theatre at Sutter and Steiner on July 1, 1949. The No. 2 car line had one more day to run. (Courtesy Al Thoman.)

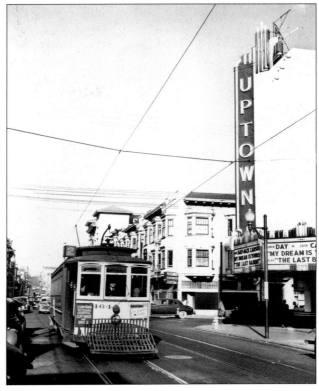

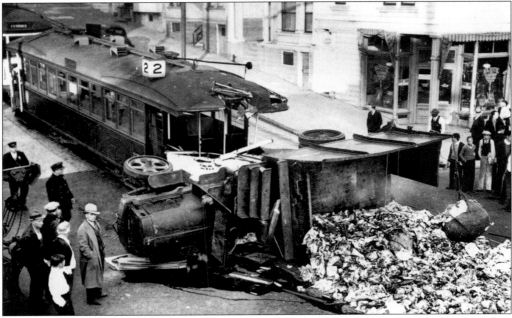

What a fine mess! A scavenger truck came out second best in this match up with car 255 at Lyon and Sutter. Recycling and workplace safety rules have changed since 1936. (Courtesy Rudy Brandt.)

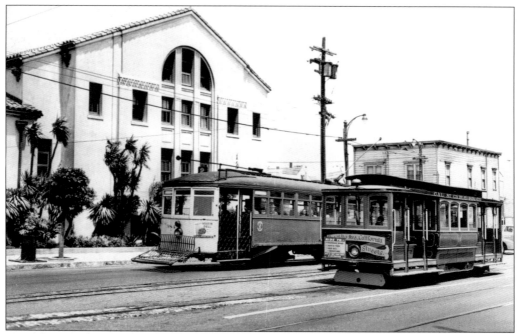

The last day of the No. 2 line was July 2, 1949. The frame house in the background was razed in the 1950s, the California Cable left Presidio Avenue in 1954, and the Jewish Community Center was demolished and completely rebuilt in 2002. (Courtesy Al Thoman.)

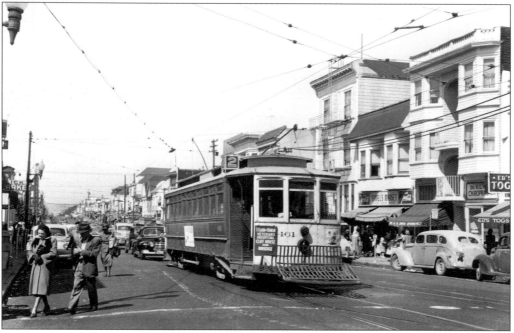

Pictured here is Sixth and Clement, the heart of the Richmond shopping district in 1949. Car 464 (ex-164) was also part of Muni's renumbering as the 100s conflicted with Muni's 100s. (Courtesy Walter Vielbaum.)

16

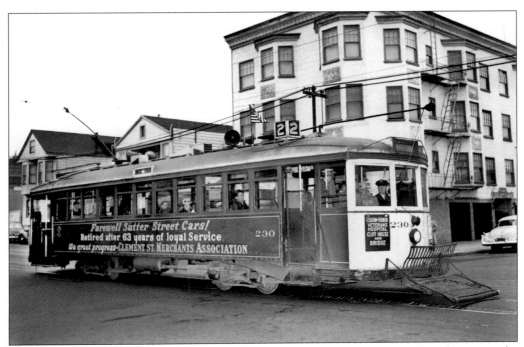

The last car on the last MSR line, car 230, is on Clement at Thirty-first heading downtown for its final trip. Loudspeakers are blaring public address announcements. A following "super twin" motor coach had trouble keeping up as car 230 rang down MSR in a grand manner. (Courtesy Al Thoman.)

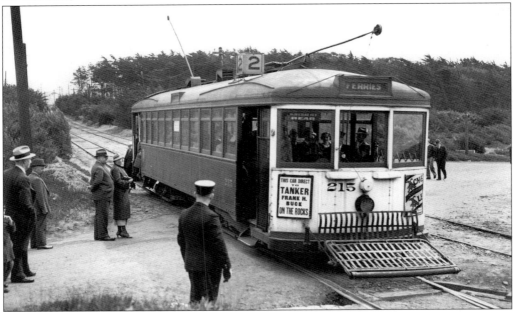

"Frank Buck on the Rocks" was not a popular drink but a tanker beached on the cliffs below the hairpin turn near Sutro Baths. This 1937 disaster was a boon for the No. 2 line, as onlookers traveled to see the ship. (Courtesy Will Whitaker.)

Countless tourists saw this scene at the Sutro Terminal. This section of the No. 1 and No. 2 lines was one of the few stretches of MSR's private right of way. (Courtesy Al Thoman.)

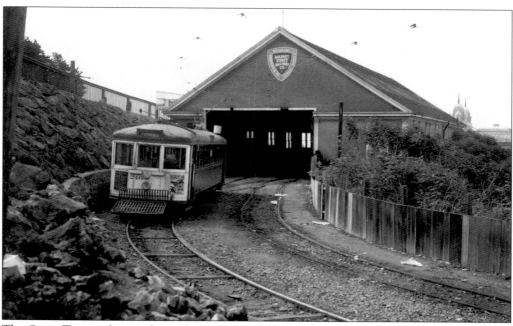

The Sutro Terminal was a busy place on Sundays. There was a refreshment stand inside that had the best peanuts this side of Georgia. The towers of "Tropic Beach" (Sutro Baths) are in the background. (Courtesy Will Whitaker.)

This is what the Sutro Terminal looked like on a busy Sunday. The No. 2 line ran here all day, while the No. 1 line only ran here in the afternoon. (Courtesy Gerald D. Graham.)

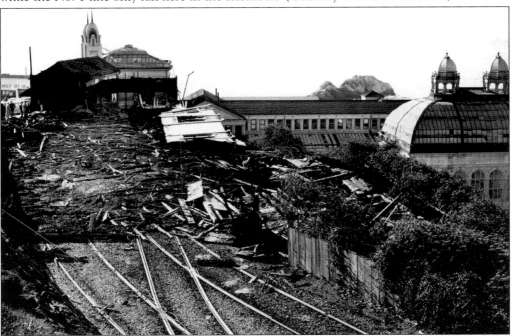

The Sutro Terminal was destroyed by fire on February 12, 1949. The Sutter lines were scheduled for bus replacement in July, so streetcar service was cut back to Forty-fifth and Geary. The Sutro Baths were not affected and lasted another 15 years before succumbing to a similar fate. (Courtesy Gerald D. Graham.)

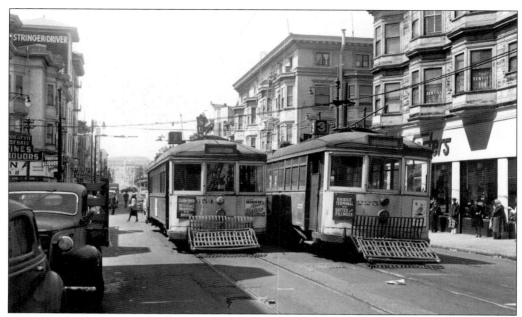

When the No. 22 Fillmore line was bussed in 1948, the No. 3 Jackson was cut back to Sutter and Fillmore, becoming a short-trip Sutter route. The trolley coach overhead is already on Fillmore in this 1949 view. (Courtesy Walter Vielbaum.)

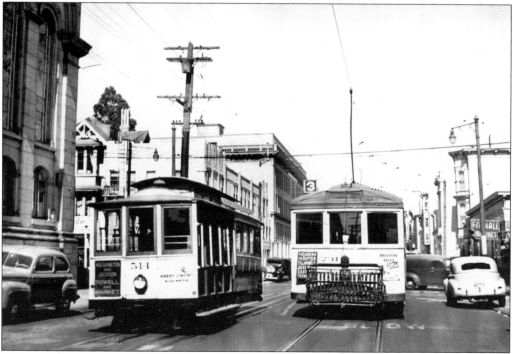

The Calvary Presbyterian Church still stands at Jackson and Fillmore. The No. 3 line had only one more week to run before its end in July 1948. The Washington–Jackson cable would last another eight years. (Courtesy Al Thoman.)

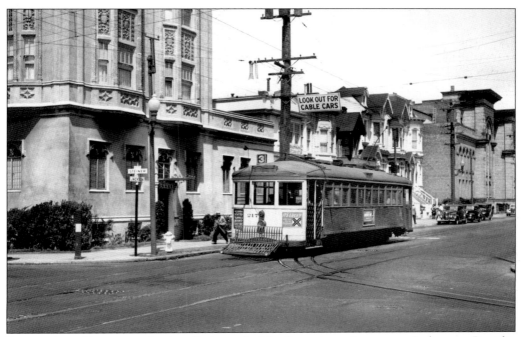

Passing the cable car turn back at Steiner, the No. 3 continues its run out Jackson to Presidio and down to California, which was the outer terminal of the Jackson cable until 1906. (Courtesy Walter Vielbaum.)

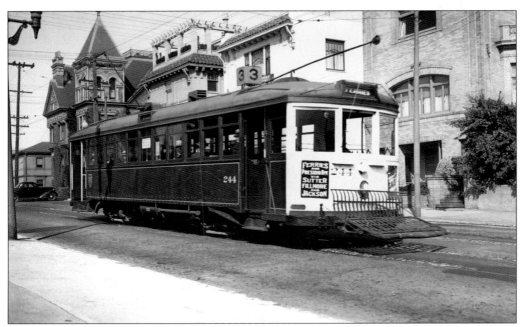

Passing the Dickens-looking Town School for Boys in 1937, No. 3 car 244 goes by Scott Street and the Alta Plaza Park on its way down Jackson to the Ferries. (Courtesy Philip Hoffman.)

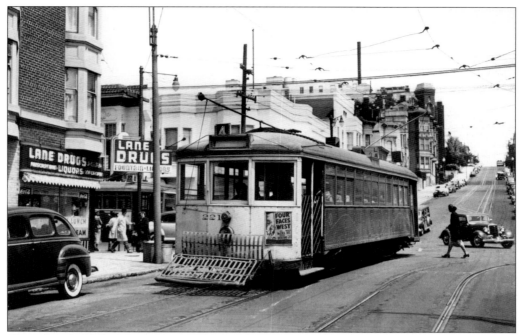

On its last day, July 31, 1948, No. 4 car 221 has just turned off Fillmore onto Sacramento. The abandoned cable car tracks and the old Stanford Hospital are in the background. (Courtesy Walter Vielbaum.)

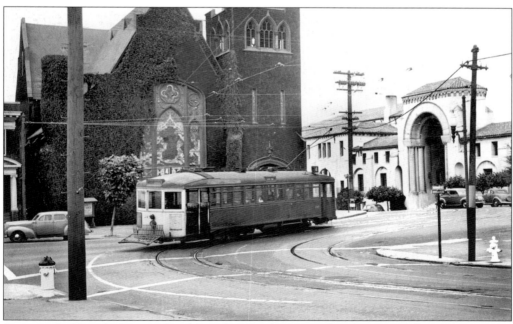

Swinging by Temple Emanu-el and St. John's Presbyterian Church on Arguello Boulevard, No. 4 car 215 will head down Sacramento Street toward the East Bay Terminal. (Courtesy Al Thoman.)

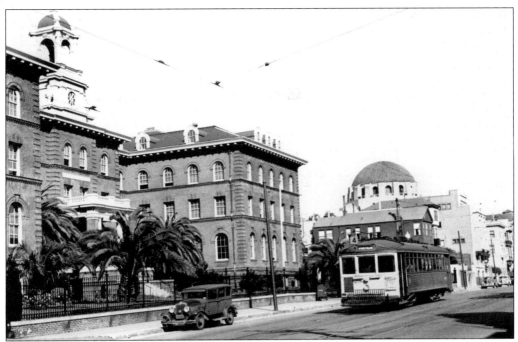

Passing by the classic Little Sisters of the Poor home on Lake Street at Third Avenue, a No. 4 car is on its way to Golden Gate Park. The Temple Emanu-el dominates the background of this 1940 view. (Courtesy Al Thoman.)

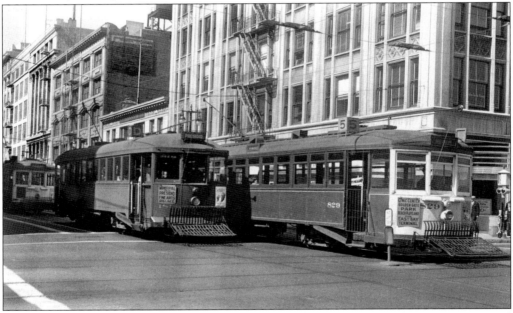

First and Mission could be a very busy place, as this 1939 photo shows. Both Muni "D" 181 and No. 5 car 829 are San Francisco products. Bethlehem Steel built car 181 for Muni in 1923 and the Market Street Railway built car 829 in its own shops in 1926. Car 181 was the last two-man car to operate in regular service in May 1958. (Courtesy Walter Vielbaum.)

June 5, 1948, was the last day of the No. 5 line. The No. 5 had been terminating at Market due to the reconstruction of the Market track, which did not include switches at McAllister in the plan. Two old San Francisco firms are in the background—Sterling Furniture and Weinstein's. (Courtesy Al Thoman.)

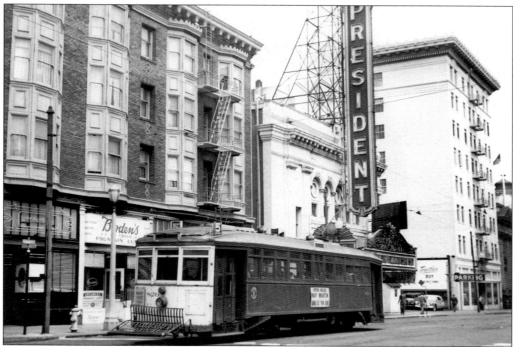

This was the last day of streetcar operation at McAllister and Leavenworth. Lon Chaney played at the President in the good old days of vaudeville, but by 1948, the President was a burlesque house. (Courtesy Al Thoman.)

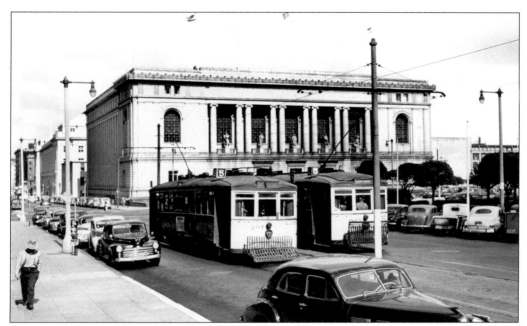

Two No. 5 cars pass near the San Francisco Public Library in 1948. To enhance the beauty of the Civic Center, both McAllister and Larkin Street (No. 19 line) had center poles that emphasized the wide boulevard look. (Courtesy Walter Vielbaum.)

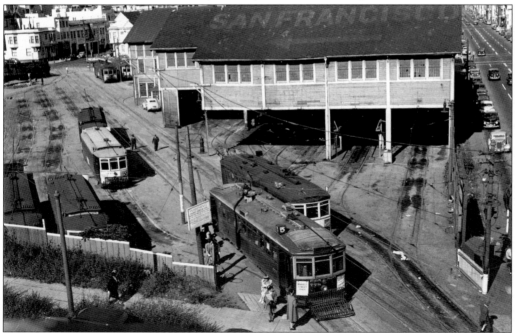

It must be rush hour, as the barn is empty. This c. 1880 structure was built for the cable system. The No. 5 was one of the few MSR lines to run through its barn. When this site was excavated in 2002 to make room for condominiums, the crew struck cable system sheaves, pulleys, and other paraphernalia. (Courtesy Walter Vielbaum.)

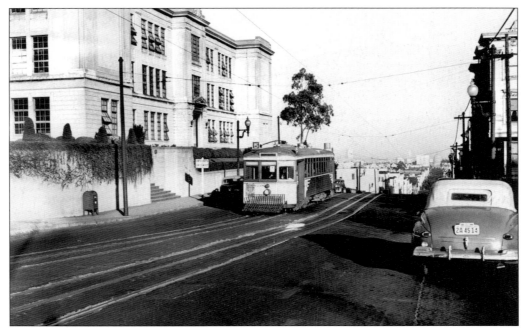

Pictured here is car 698 on the No. 5 line passing by the University of San Francisco at Fulton and Cole in 1947. The slot remained for 41 years after cable service ended! City hall is in the background. (Courtesy Walter Vielbaum.)

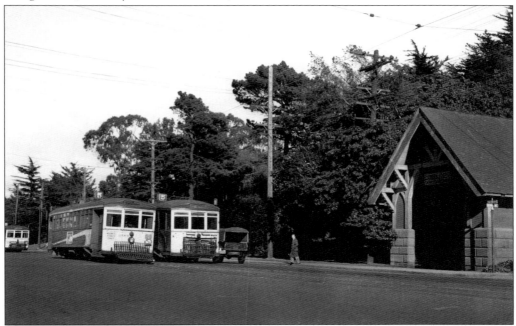

Here is a little activity on the No. 5 line at Seventh Avenue and Fulton in 1948. The Ferries and Cliff House waiting station still remained—46 years after the last steam train's departure. It continues to stand today, a further 56 years after the No. 5 car's last run. (Courtesy Walter Vielbaum.)

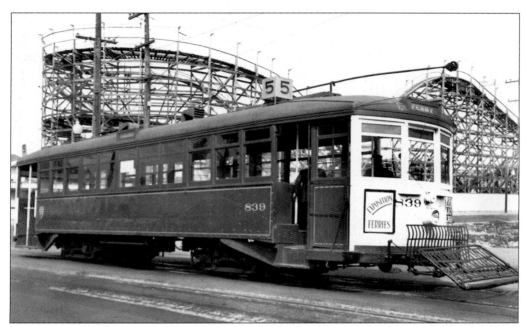

Car 839 switched back at Fulton and La Playa on this trip in 1939. "Exposition" is the Golden Gate International Exposition on Treasure Island. Playland's Big Dipper occupies the background. (Courtesy Will Whitaker.)

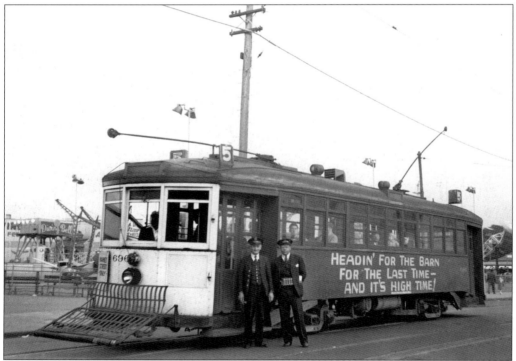

Car 696, the very last No. 5 car, poses on La Playa near Cabrillo. Behind the car is Playland's Diving Bell. (Courtesy Al Thoman.)

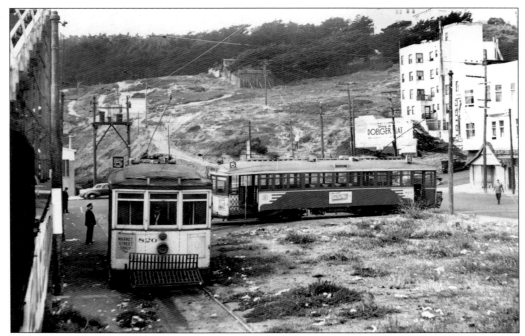

In this Playland scene, Sutro Heights is in the background and part of the Chutes is on the left. This terminal at Balboa and La Playa was MSR's only loop—besides the ferry and the East Bay Terminal. (Courtesy Al Thoman.)

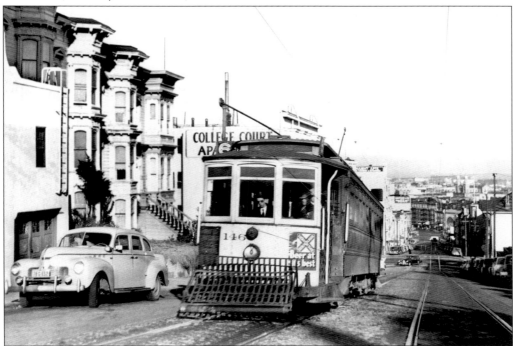

Looking down to Market Street, No. 6 car 146 crests the Haight Street hill at Buchanan. (Courtesy Al Thoman.)

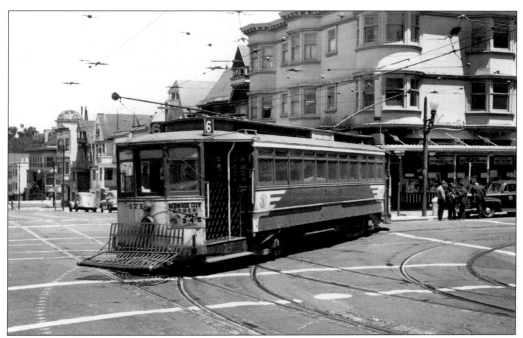

In the heart of the "Hashbury" (as the Haight-Ashbury district became known in later hippie years), No. 6 car 471 (ex-171) makes one of its final turns from Haight onto Masonic on the last day of streetcar operation, July 3, 1948. The 471 will have a reprieve, however; it will move to the Sutro Barn and service the No. 1, No. 2, and Muni "C" lines. (Courtesy Al Thoman.)

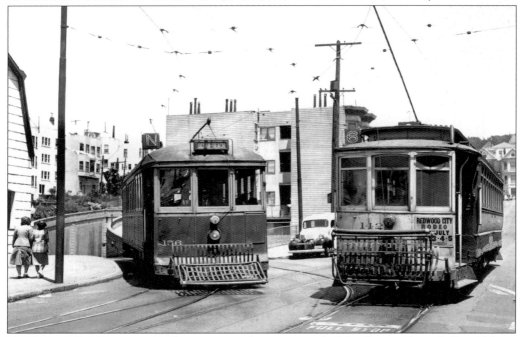

Two Jewett Car Company products meet at the west portal of the Sunset Tunnel. Car 156 was built for Muni in 1914, the 142 for the URR in 1911. (Courtesy Walter Vielbaum.)

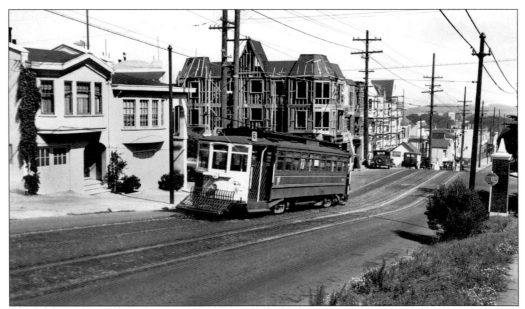

Climbing Ninth Avenue toward Pacheco in 1939 is No. 6 car 170. From 1913 to 1948, the No. 6 used only one type of car—these deck-roofed 100s. If you look closely between the telephone poles in the distance, you will spot the De Young Museum that was razed and completely rebuilt in 2004. (Courtesy Will Whitaker.)

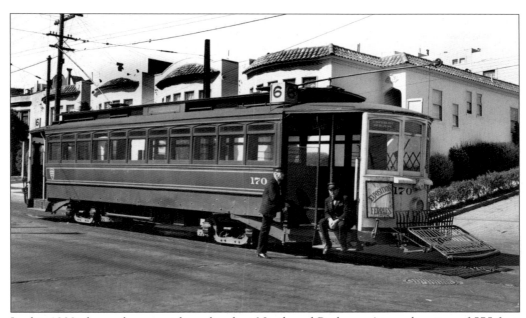

In this 1939 photo, the crew takes a break at Ninth and Pacheco. At an elevation of 575 feet, this was the highest point in San Francisco reached by streetcar. MSR had a rule that roof number plates be in all corners on all cars that used the inner tracks on Market Street. (Courtesy Will Whitaker.)

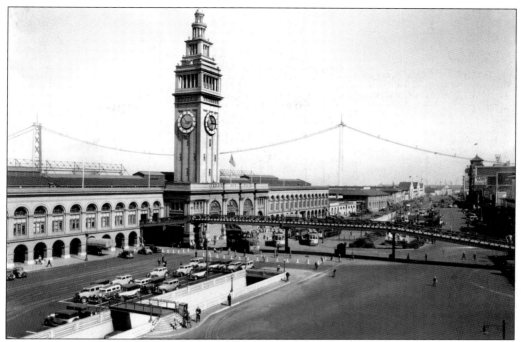

There are all kinds of eye catchers in this 1935 photo: vintage taxicabs, No. 7 car 110 and a No. 21 "Chicago car" on the ferry loop, Sacramento-Clay cable car track, and a roadless Bay Bridge. We can see the original "Market Street subway," which allowed traffic to pass under the ferry loop at the foot of Market Street, as well as the pedestrian overpass that was torn down in 1942. (Courtesy SF City Engineer/Richard Schlaich.)

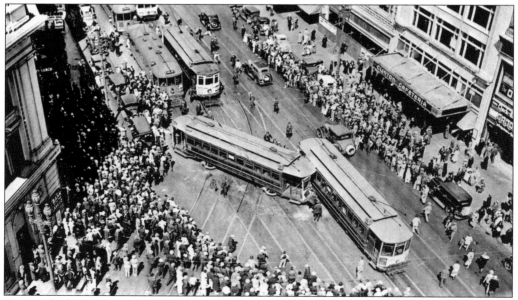

Oops! The back wheels of No. 7 car 119 decided to be a No. 5 and go out McAllister Street. When this mess is straightened out, some in the crowd will return to the Clinton cafeteria to finish their meals. (Courtesy Philip Hoffman.)

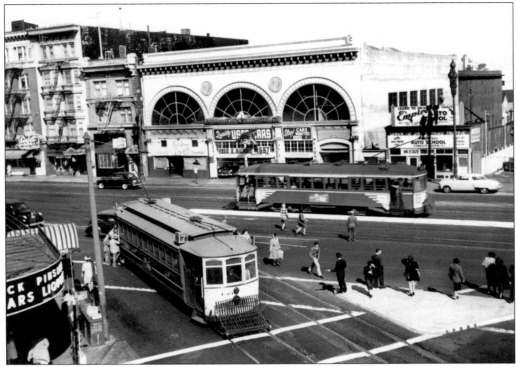

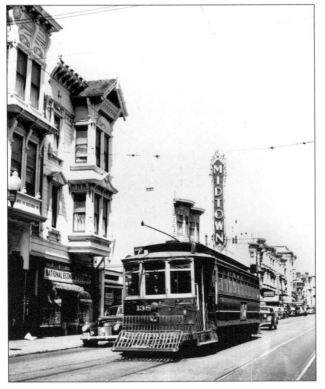

The last Haight Street car turns off Market. The No. 7 car 439 will go out Haight, Stanyan, and Lincoln Way to Forty-eighth, change ends, and pull in the yard at Fourteenth Avenue. The students of Poly High and patrons of Kezar Stadium will have to use the "N" line on Carl for decent transportation. (Courtesy Al Thoman.)

In its last week of operation, the No. 7 car 138 glides by the Midtown Theatre (now a church) on Haight near Steiner. At this time in 1948, San Francisco had an Uptown, Midtown, and Downtown Theatre. (Courtesy Al Thoman.)

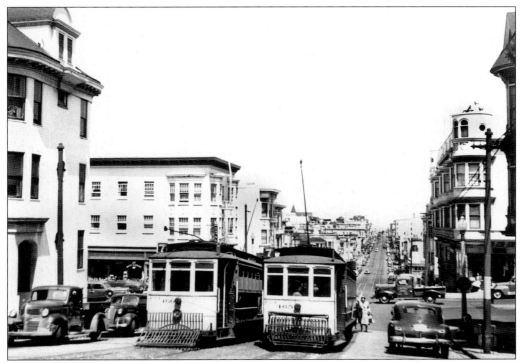

During this evening rush hour in 1948, three outbound cars can be seen in five blocks. Car 460 also went over to the "C" line when the No. 7 closed and was the last car taken out of the Funston "Bone Yard" in October 1949. (Courtesy Al Thoman.)

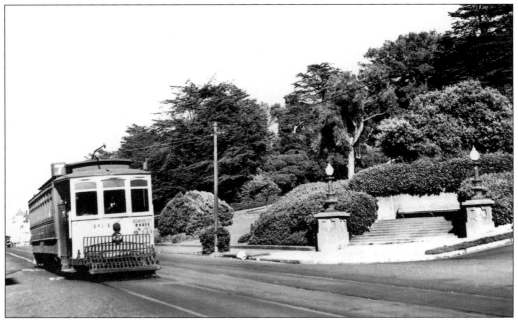

Speeding along a car-less Haight Street in 1948, No. 7 car 164 is at Buena Vista West between Lyon and Central Avenues. (Courtesy Al Thoman.)

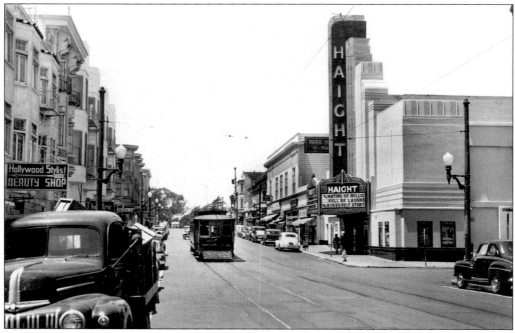

By 1948, there was no longer any angled parking on Haight Street. This No. 7 is passing the Haight (later Straight) Theatre at Cole Street. (Courtesy Walter Vielbaum.)

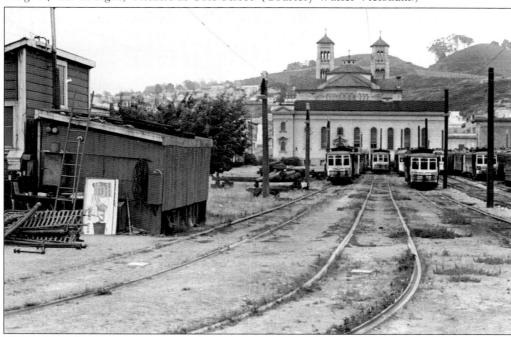

This is how the Funston "Bone Yard" on Lincoln Way looked in 1943. The deck-roof 100s in the foreground are No. 7 and No. 17 cars laying over. The arch-roof cars active behind them are sleeping out the war because there is no manpower to run or repair them. (Courtesy Richard Schlaich.)

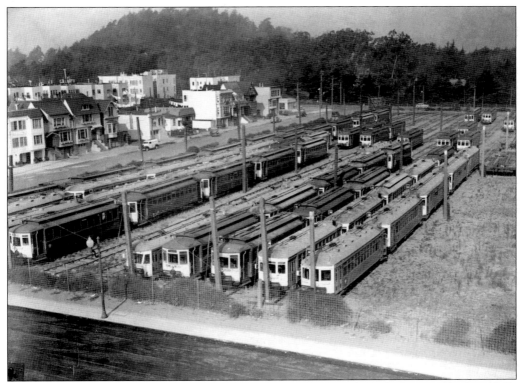

In the foreground of this view, looking north from Irving Street through Funston Yard in 1940, are outlawed one-man cars from Williamsport and East St. Louis. About two-dozen 1600s can also be seen, all of which were scrapped in 1941. (Courtesy Philip Hoffman.)

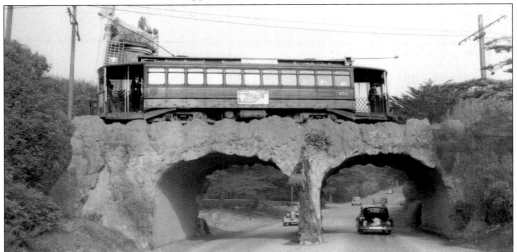

This is not Holland, but rather Golden Gate Park. In this 1945 view, No. 7 car 154 with its ends painted blue and yellow roars over the South Drive bridge. In 1947, the bridge was deemed unsafe for streetcars and the No. 7 terminal had to be moved to Forty-eighth and Lincoln Way. The bridge became a bridle path, but even horses were too much for it and it was torn down. (Courtesy Tom Gray.)

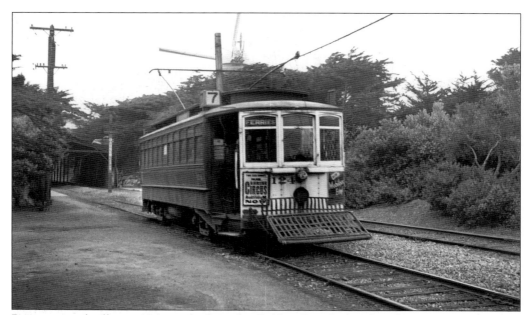

Between windmills, car 124 speeds along the Golden Gate Park right-of-way in 1937. This was originally part of the Park & Ocean Railway that opened in 1883, long before park superintendent John McLaren's ban on railways through the park. Streetcars took over in 1898. (Courtesy Will Whitaker.)

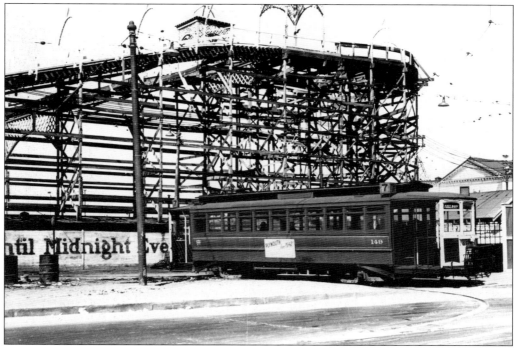

No. 7 car 149 lays over alongside the famous Chutes at the Playland loop in 1941. The Chutes got so rickety it had to be taken down about five years before Playland closed. (Courtesy Al Thoman.)

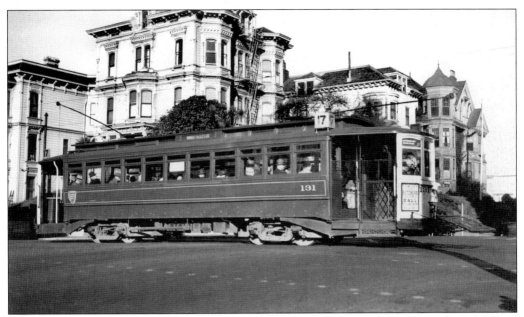

At the top of the hill at Buchanan Street, No. 17 car 131 is about to descend Haight to Market. All the buildings in this scene were replaced by a housing project. You can tell this is a prewar shot because the car's jumbo side roller sign is visible. All were painted over in 1940. (Courtesy Will Whitaker.)

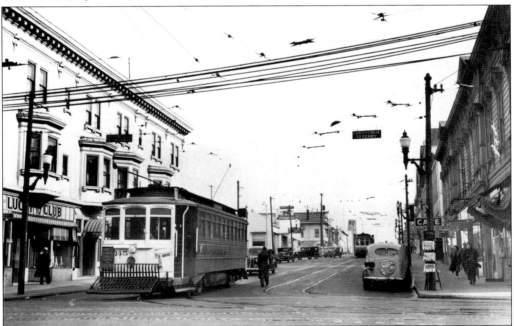

This is No. 17 car 145 at Haight and Stanyan in the late 1930s. The 1938 DeSoto taxi and the "honor system" news rack add a little nostalgia to this scene. The trolley coach overhead is another rarity as San Francisco had only one trolley coach line at the time. (Courtesy Al Thoman.)

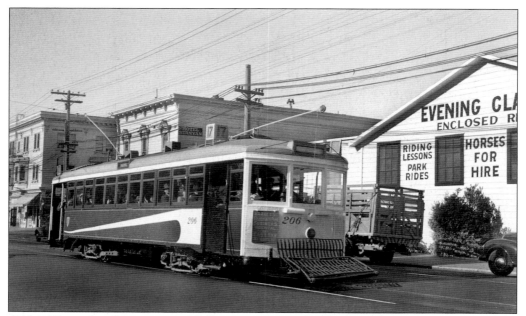

A No. 17 car plies Stanyan near Waller. It is 1943 and with gas rationing people could rent a one-horsepower conveyance here. Car 206 illustrates the snazzy Art Deco paint scheme of 1939. (Courtesy Will Whitaker.)

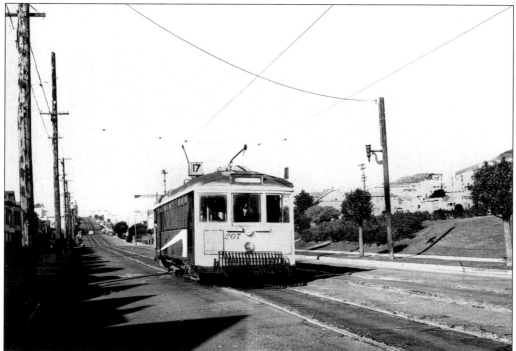

Pictured here is Twentieth Avenue near Vicente. Car 207 usually ran on the No. 8 line, but the Haight barn foreman would occasionally assign the 200s to the No. 7 and No. 17 line but never the No. 6—probably because of its many turns. (Courtesy Will Whitaker.)

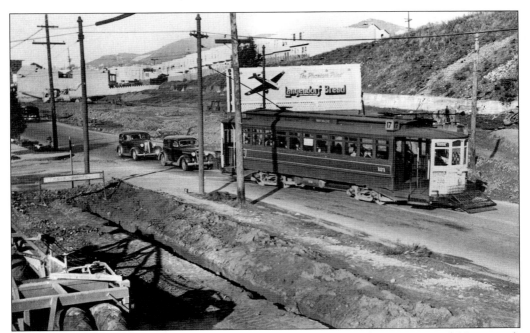

This is one of the last days of service on Nineteenth Avenue. The No. 17 used Nineteenth Avenue to connect with Sloat Boulevard for Sunday zoo service. The widening of Nineteenth Avenue cut the No. 17 back to Wawona in 1937. To compete for the zoo business, Muni extended the "L" line down Forty-sixth toward Sloat the same year. (Courtesy Al Thoman.)

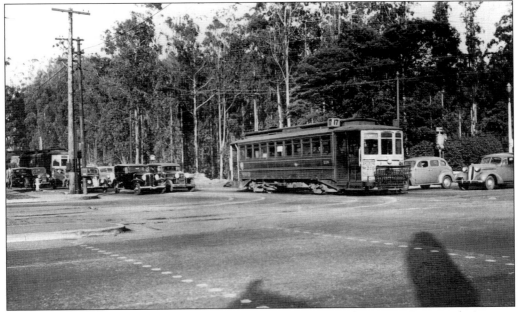

In this 1937 photo, car 118 has just made a difficult left turn off Sloat onto Nineteenth Avenue. The 1937 Plymouth and 1936 Pontiac are raring to take off. Sigmund Stern Grove is off camera to the left. (Courtesy Al Thoman.)

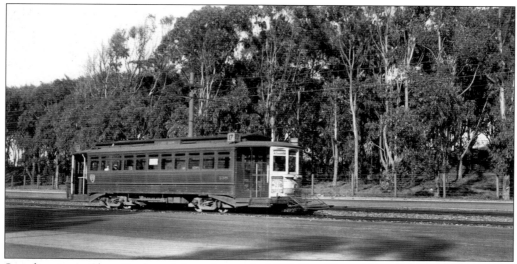

Speeding in on Sloat Boulevard from the zoo in 1937, No. 17 car 138 will turn up Nineteenth Avenue to Wawona and then traverse Twentieth Avenue to Lincoln Way. The No. 17 was the only car line to serve both Golden Gate Park and the zoo. (Courtesy Will Whitaker.)

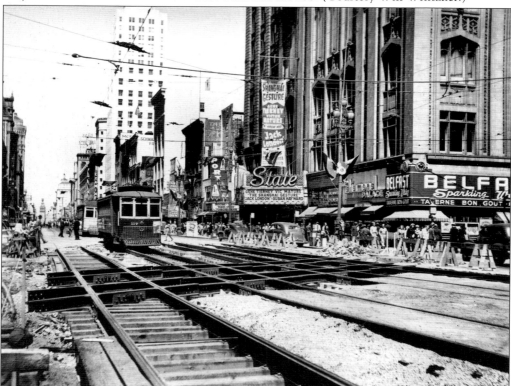

Muni is well into construction of its "F" Line Southern Pacific Depot extension, which only lasted until 1951. At Fourth and Market in 1947 one had the choice of riding No. 21 car 117, attending the State or Portola Theatres, or having your teeth cleaned at Painless Parker the Dentist. (Courtesy Al Thoman.)

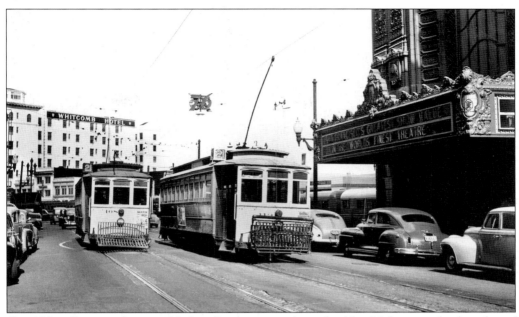

Car 108 pulls away from its Market Street terminal on the No. 21 line on the last day of streetcar service—June 5, 1948. The Fox Theatre's Hayes Street side can be seen to the right of car 113. Both cars saw a few months further service on Mission Street. (Courtesy Walter Vielbaum.)

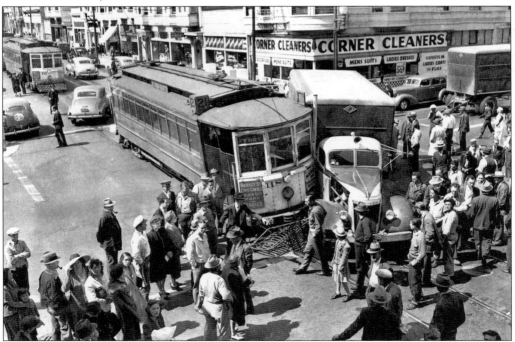

The big rigs can't bully everyone! While *Holiday Inn* is playing at the Paramount, No. 21 car 118 had a little right-of-way dispute in the heart of the Hayes Valley at Gough Street. (Courtesy Philip Hoffman.)

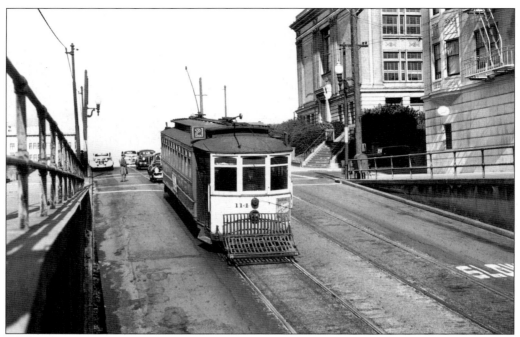

Looking east at Pierce in 1948, the elevated sidewalks show the original level of Hayes Street in cable car days. In 1916, a cut was made so streetcars could negotiate an easier grade. (Courtesy Walter Vielbaum.)

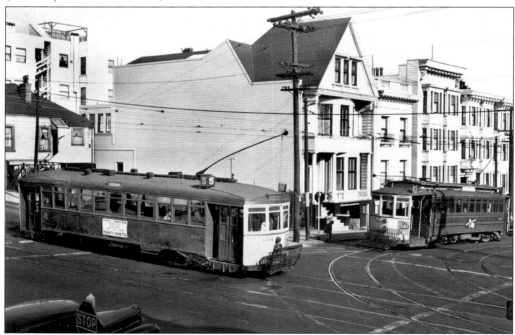

The last day the intersection of Fulton and Stanyan would hear the clang of streetcars was June 5, 1948. Many of the buildings on the right were razed for a St. Mary's hospital annex. (Courtesy Walter Vielbaum.)

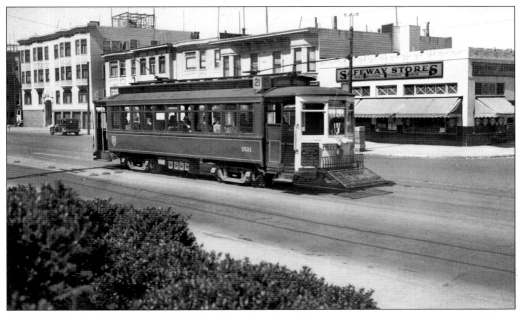

At Fulton and Fifth Avenue in 1937, a No. 21 car passes one of the many Safeway stores that graced San Francisco's neighborhoods. Car 1511 is a "Chicago" type car. In a 1906 gesture of goodwill, Chicago diverted an order of 50 cars as earthquake relief. While San Francisco's "Chicagos" were all retired by 1939, their mates in the Windy City lasted 12 years longer. (Courtesy Will Whitaker.)

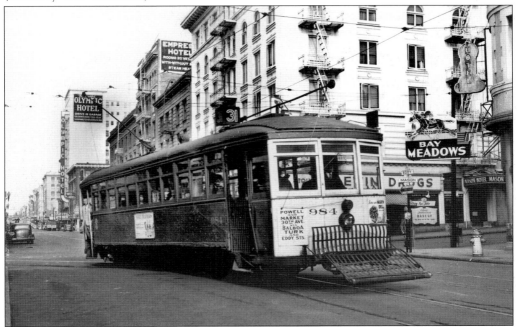

This "Tenderloin Toonerville" (as the 31 line was affectionately called) turns from Mason onto Eddy in its last month of operation. The 17-year-old "Balboa High Speed" 984 will be retired by year's end. (Courtesy Will Whitaker.)

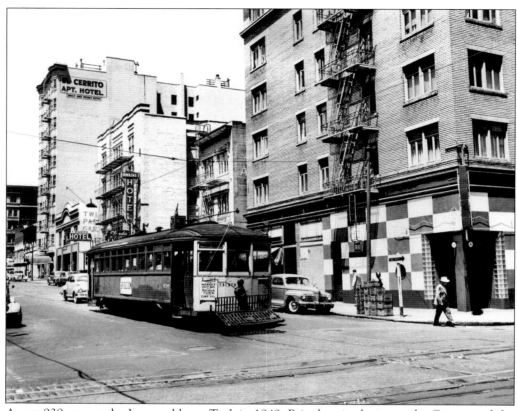

As car 939 crosses the Jones cable on Turk in 1949, *Brigadoon* is playing at the Curran and the Jones Street shuttle has another five years to run. (Courtesy Al Thoman.)

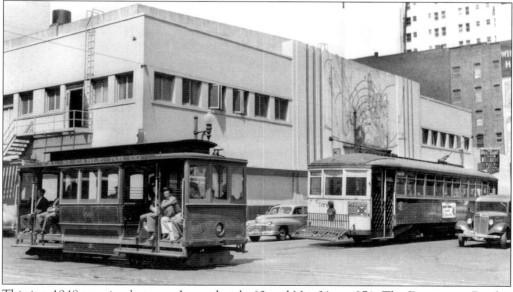

This is a 1948 meeting between Jones shuttle 60 and No. 31 car 971. The Downtown Bowl is now a Tenderloin mini-park. (Courtesy Tom Gray.)

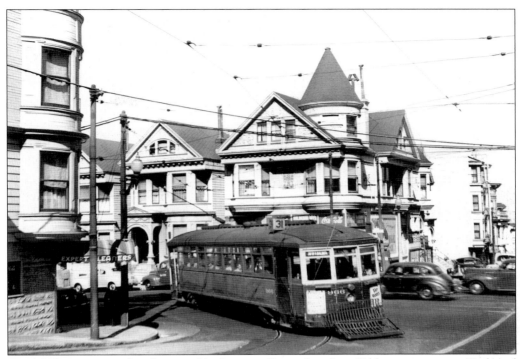

Car 966 has just completed its one block jog on Divisadero from Eddy to roar out on Turk and Balboa and continue to Thirtieth Avenue. It is 1948 and all other rail lines on Divisadero have been abandoned. (Courtesy Al Thoman.)

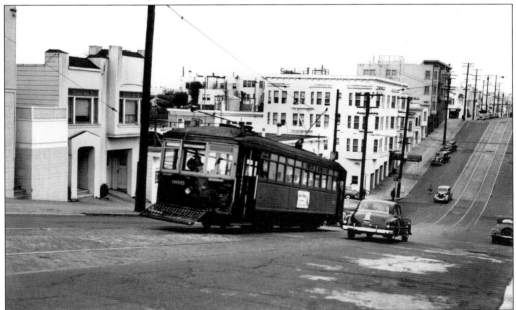

Two of the highest sand dunes in the outer Richmond District caused the famous Balboa "dip." The crews must have hated to stop at the bottom at Twenty-third Avenue. Car 966 is making one of its final trips on the No. 31's last day. (Courtesy Will Whitaker.)

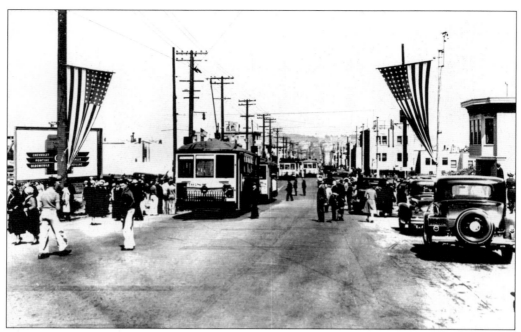

In this opening day photo taken May 15, 1932, at the outer terminal of the No. 31 at Thirtieth Avenue, the Balboa dip is visible in the distance. Ironically, car 968 was the last No. 31 car closing the service on July 2, 1949. (Courtesy MSR/Richard Schlaich.)

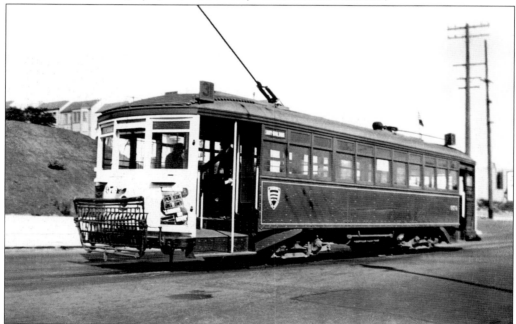

Ladies in Love is playing at the Warfield in this 1936 view at Thirtieth and Balboa. Car 974 was purchased by the Bay Area Electric Railroad Association in 1950 but unfortunately was destroyed by vandals within 10 years and never ran at their museum at Rio Vista Junction. (Courtesy Will Whitaker.)

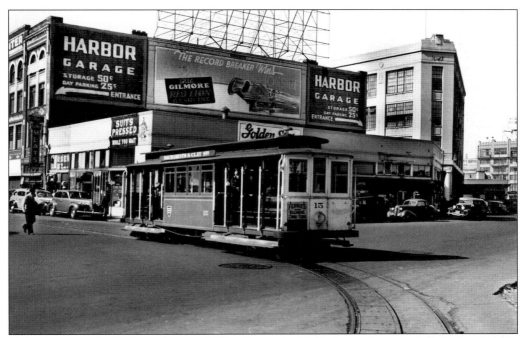

This photo at the Embarcadero and Clay Street in 1940 shows the area before the Golden Gateway development was built. Car 15 and its mates were the largest cable cars to run after 1906. (Courtesy Will Whitaker.)

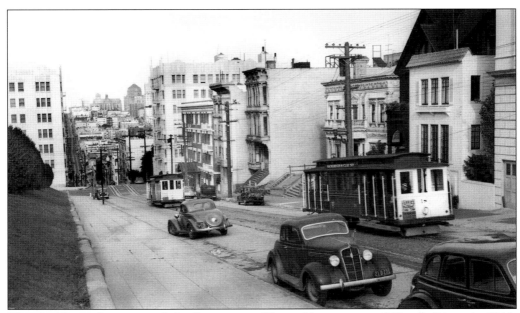

This double track portion of the Sacramento-Clay cable ran west of Gough Street in 1941. Casual parking prevails along Lafayette Park on the left. (Courtesy Philip Hoffman.)

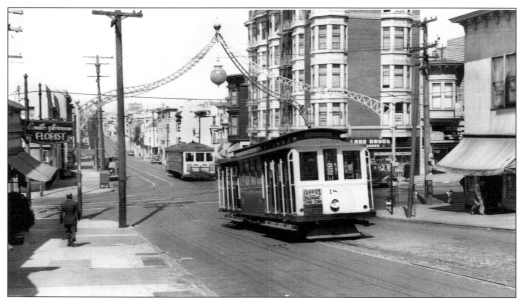

The intersection illumination seen in this view of Sacramento and Fillmore about 1940 was a wartime victim of blackouts and scrap drives. Before 1906, the cable went all the way to Walnut Street (where it had been cut back from its Golden Gate Park Terminal in 1902). (Courtesy Tom Gray.)

Going up? The elevator at the Washington-Mason car barn hoists Sacramento–Clay Car 21 from Mason in 1941. (Courtesy Philip Hoffman.)

Two
SOUTH OF
MARKET LINES

Line 8) Market
Line 9) Valencia
Line 10) Sunnyside
Line 11) Mission and Twenty-fourth Street
Line 12) Ingleside
Line 14) Mission
Line 26) Guerrero
Line 35) Howard
Line 36) Folsom
South City Line

Two of these lines ran on Market, five on Mission, and one each on Howard and Folsom. A former cable line, the No. 8 ran the full length of Market, then down Castro to Eighteenth Street. The hilly outer section of Castro remained an isolated cable line until 1941. After the adjustments of 1935, the No. 9 line, which ended at Twenty-ninth and Noe, got an additional destination—Cortland and Banks. In 1939, the No. 9 received a third terminal—Daly City. A gradual decline began after 1940, resulting in the No. 9 becoming a short run of the No. 14 by 1949. One of the few wartime abandonments of the MSR was the No. 10, which had off-peak bus service since 1940. Branching off Mission at Twenty-second, the No. 11 jogged over Chattanooga and then turned on Twenty-fourth Street, climbing the hills to Hoffman Avenue. Its route remained unchanged for 54 years. Running from the zoo to the ferry via Sloat, Ocean, and Mission, the 10-mile long No. 12 was San Francisco's longest streetcar line. In an unusual example of cooperation, the No. 12 shared trackage with Muni's "K" line on Ocean and Junipero Serra for about 1 mile. Replaced by the No. 9 line in 1939, the No. 26 had a two-year wartime restoration. Parts of the No. 26 have been re-railed as extensions of Muni's current "J" and "M" lines.

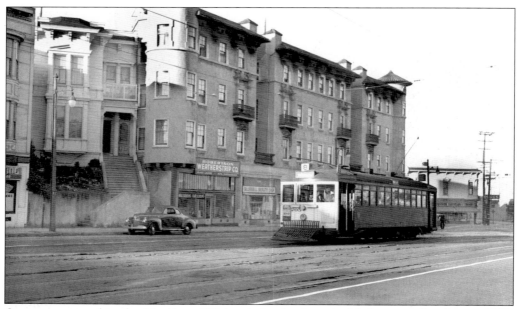

On its own set of tracks, No. 8 car 205 heads for the ferry on Market near Sanchez in 1942. Along this section of Market Street there were two sets of tracks for three lines! (Courtesy Philip Hoffman.)

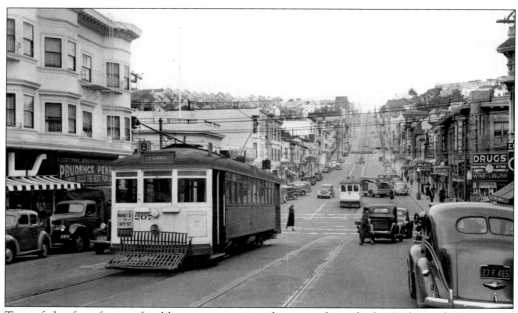

Two of the four forms of public transportation that pass through the Eighteenth Street and Castro intersection are visible in this 1941 view. Missing are Muni's No. 6 Eureka Valley bus and the No. 33 trolley coach. (Courtesy Philip Hoffman.)

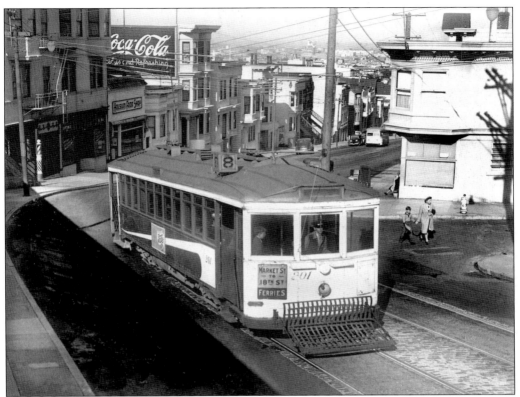

No. 8 car 201 passes Danvers Street on its Eighteenth Street rush hour extension in 1943. A 1935 Brill No. 33 trolley coach follows. (Courtesy Will Whitaker.)

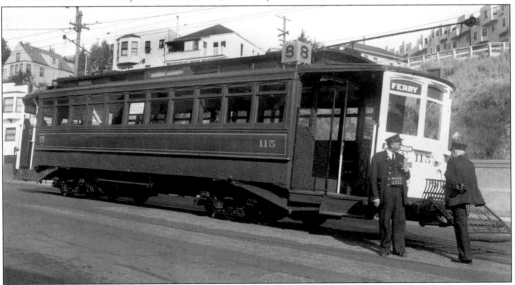

Sitting at Eighteenth Street and Caselli in 1937, the crew of car 115 awaits another run downtown. The streetcars and trolley coaches each have their own overhead—which is not a common practice. (Courtesy Will Whitaker.)

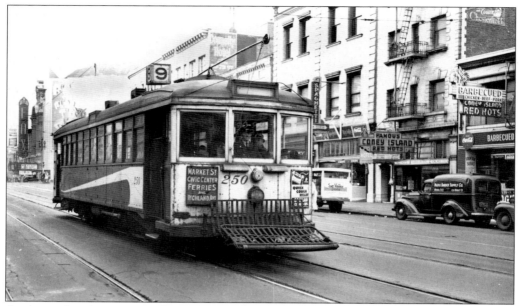

An unusual assignment is a Sutro 200 on the No. 9 line. It must be making a trial run after repairs. At Ninth and Market in 1942, *Jackass Mail* is playing at the Fox Theatre and one has a choice of restaurants for Coney Island "red hots." (Courtesy Philip Hoffman.)

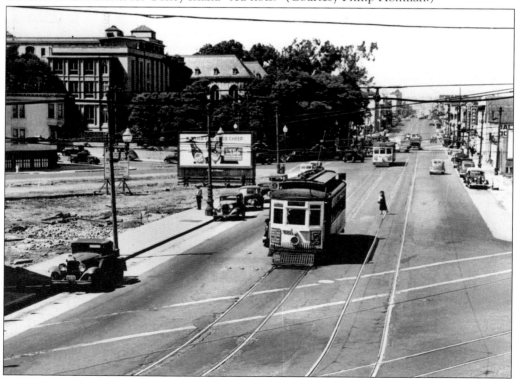

Looking down Valencia Street from Mission in 1940, the site of the Twenty-eighth Street car barn is on the left and St. Luke's Hospital is in the background. (Courtesy Richard Schlaich.)

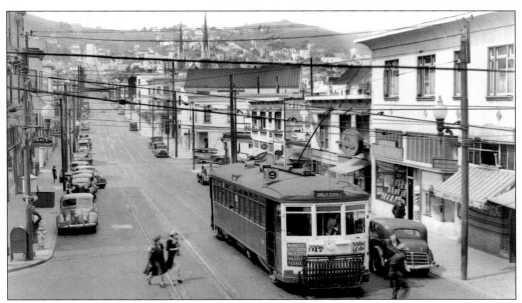

Heading out Twenty-ninth Street at San Jose Avenue on the Daly City run in 1940 is No. 9 car 917. Later 917 will be stored and spend the next five years in the Funston storage facility. (Courtesy Tom Gray.)

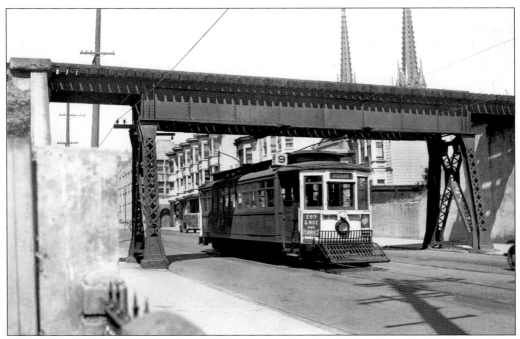

On a sunny day in 1937, No. 9 car 1577 passes under the old Southern Pacific Ocean View Branch on Twenty-ninth Street. Before the Bayshore cut-off was opened in 1907, this was the main Southern Pacific line to San Jose. It was closed in 1942. The twin spires of St. Paul's Church dominate the neighborhood. (Courtesy Will Whitaker.)

Approaching Twenty-ninth Street on Mission in 1946, gaudily painted No. 9 car 284 rumbles past the Lyceum Theatre where *Two Years Before the Mast* is playing. (Courtesy Philip Hoffman.)

Leaving the single-track portion of Cortland Avenue, No. 9 car 936 gets the "go" sign from the birdcage signal to enter Mission Street. Notice the absence of automobile traffic in prewar 1939. (Courtesy Richard Schlaich.)

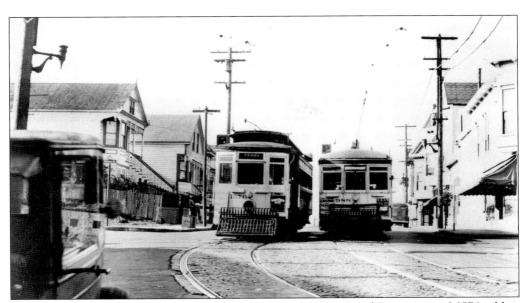

On the passing track atop Bernal Heights on Cortland Avenue and Bennington, MSR's oldest and newest cars pass. The 1576 was a St. Louis Car Company product of 1907 while the 988 was built in the company's Elkton Shops in 1933. (Courtesy Ted Wurm.)

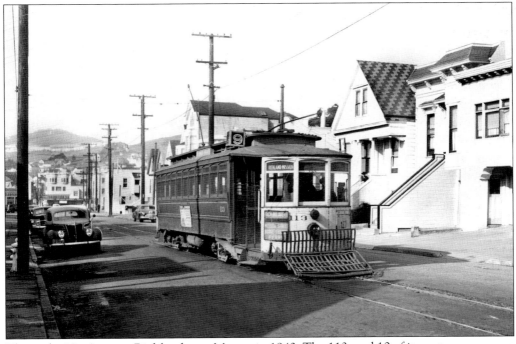

This is the No. 9 car on Richland near Murray in 1943. The 113, and 10 of its mates, came over from Sutro for further service after the No. 21 closed in June 1948. They got new destination signs at the Geneva Divison but closed the line in January 1949. (Courtesy Walter Vielbaum.)

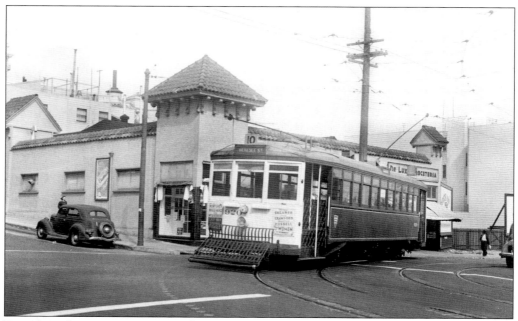

Rounding the curve at Fourteenth and Guerrero, No. 10 car 920 follows the route of the original 1891 San Francisco & San Mateo Railroad—San Francisco's first trolley line. (Courtesy Will Whitaker.)

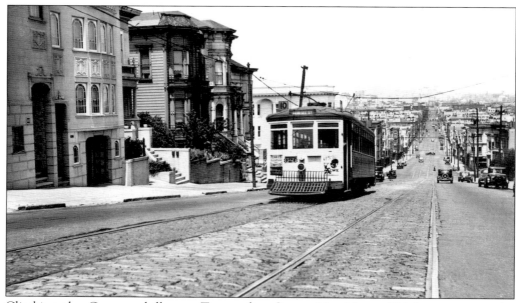

Climbing the Guerrero hill near Twenty-first Street, No. 10 car 926 bounces over the original track of the SF&SM Railway. "Poor track" was one of the reasons the No. 10 got Office of Defense Transportation approval to abandon in wartime 1942. (Courtesy Philip Hoffman.)

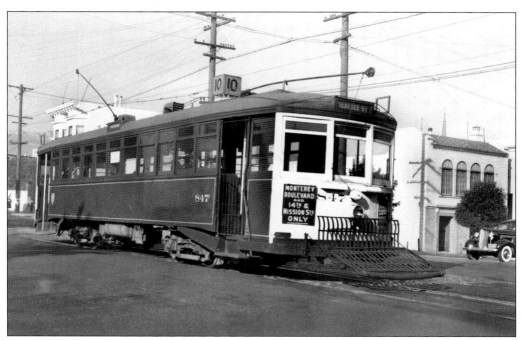

Crossing Dolores Street on Thirtieth Street, the No. 10 car is headed inbound turning back at Fourteenth and Mission. This track was torn up in 1942. The Muni's "J" extension to Balboa Park follows this route today. (Courtesy Will Whitaker.)

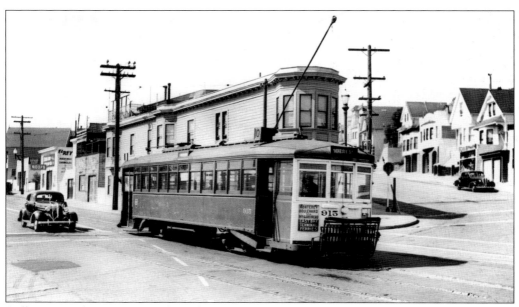

Rolling toward Monterey Boulevard, No. 10 car 915 crosses Joost on Diamond Street. The site of the later Glen Park BART Station is a block behind the car. Car 915 went to Funston storage but was rehabbed in 1946 and spent two years on the No. 5 line. (Courtesy Philip Hoffman.)

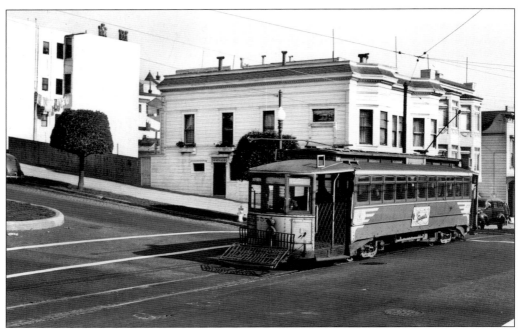

Crossing Dolores Street on Twenty-second, No. 11 car 457 has been assigned to the Geneva Barn after serving 35 years on Haight Street. Car 457 was one of seven 400s that got the new Muni wings paint scheme. (Courtesy Walter Vielbaum.)

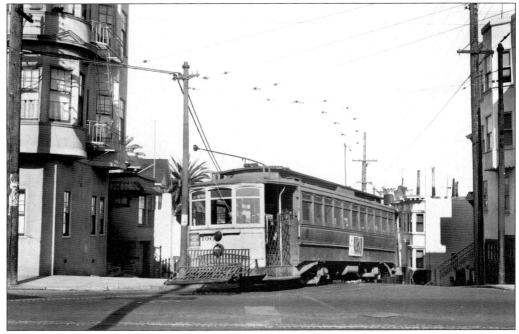

Rounding the curve onto Twenty-fourth Street, the "Chattanooga choo-choo" 106 will start its climb up the hills to Hoffman Avenue. One of the ex-MSR cars, 106 kept the end dash lights that were part of the white front patent. (Courtesy Walter Vielbaum.)

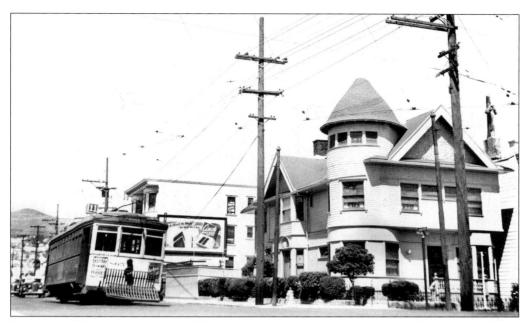

No. 11 car 805 is ready to turn off Twenty-fourth Street onto Dolores in 1948. Two blocks of single track from Twenty-fourth to Twenty-second Streets interrupted the long line of palm trees along Dolores. After the No. 11 closed in 1949, palm trees were planted on narrower islands to fill the gap. Even today they are noticeably shorter. (Courtesy Al Thoman.)

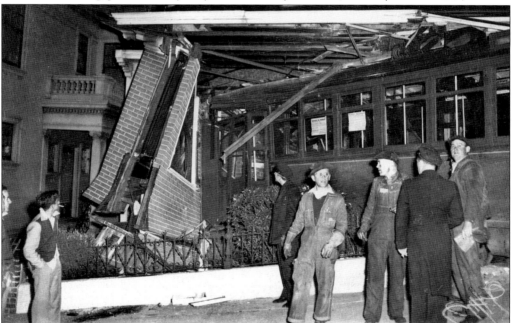

Guess who's coming for dinner? One day in 1945 No. 11 car 808 lost its brakes on the Twenty-fourth Street hill, jumped the curve at Dolores, and ended up in this house's front parlor. Car 808 and the No. 11 line are no more, but the house still stands. (Courtesy Philip Hoffman.)

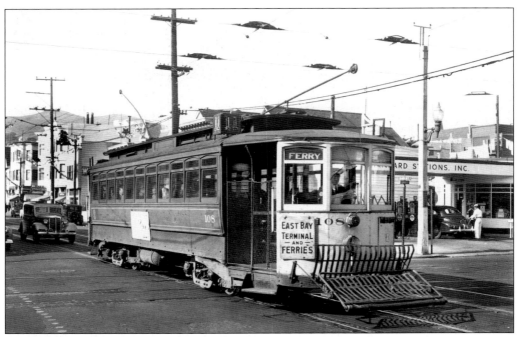

Sporting a new roller sign, No. 11 car 108 crosses Church Street at Twenty-fourth Street. One of Muni's distinctive concrete poles stands to the right of 108. (Courtesy Philip Hoffman.)

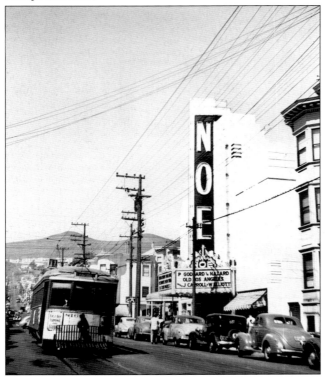

With Twin Peaks as a background, No. 11 car 816 rolls by the Noe Theatre on Twenty-fourth Street in this 1948 view. (Courtesy Walter Vielbaum.)

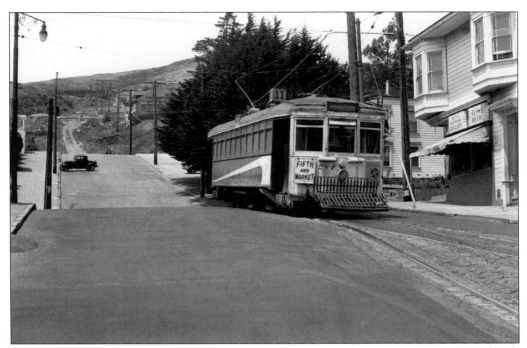

In the less urbanized setting of 1943, No. 11 car 284 awaits another departure at Twenty-fourth Street and Hoffman. Heavy wartime usage has faded the Art Deco paint scheme. (Courtesy Al Thoman.)

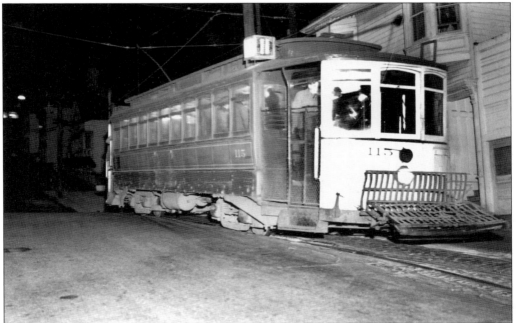

On a cold January evening, the very last No. 11 is ready to make its run to the Funston Bone Yard on Lincoln Way. The late Richard Schlaich (whose collection is the source of many of these photos) is on the front platform. (Courtesy Walter Vielbaum.)

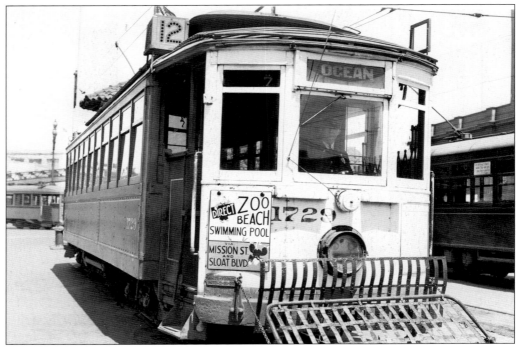

Sporting its enameled dash sign at the ferry terminal in the late 1930s, car 1729 is ready for its trek to the zoo. Car 1729 was part of the largest streetcar order in San Francisco—200 cars from the St. Louis Car Company in 1907. (Courtesy John G. Graham.)

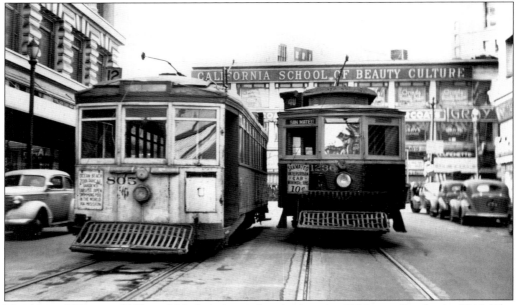

No. 12 car 805 sits at Fifth and Market alongside suburban car 1236 on a Sunday in 1946. The San Mateo–bound 40 line at right is explored in Arcadia's *San Mateo Interurban* book. The California School of Beauty Culture was demolished for an extension of Fifth Street. (Courtesy Al Thoman.)

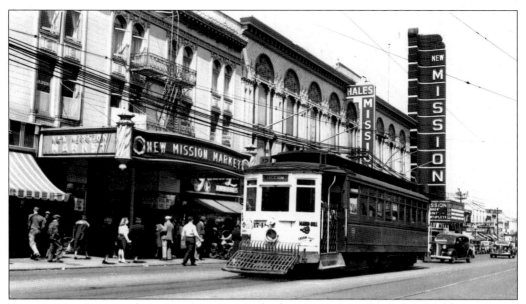

Nearing Twenty-second Street on Mission in the late 1930s, No. 12 car 1748 is bound for the zoo. The new Art Deco–style Mission Theatre still stands but awaits an uncertain future. (Courtesy Philip Hoffman.)

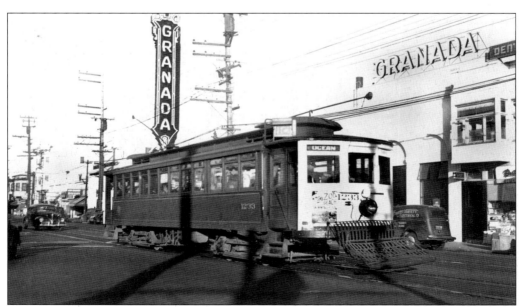

Suburban car 1233 is deep in the Excelsior District at Mission near Brazil. In 1943, the Granada Theater was the leading outer-Mission theatre. (Courtesy Philip Hoffman.)

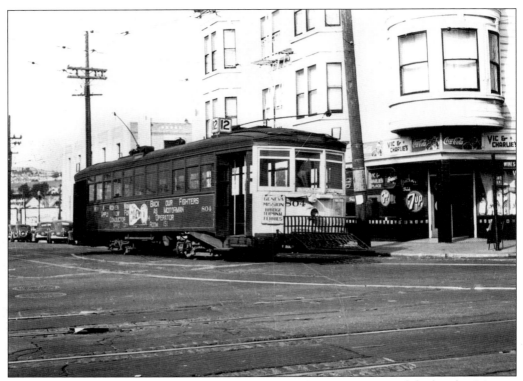

There must be a problem as this car is running empty and wrong-way-round the bend at Mission and Onondaga. In this 1945 view, an Acme beer advertisement is plastered over the employment message painted on this side of car 804. (Courtesy Walter Vielbaum.)

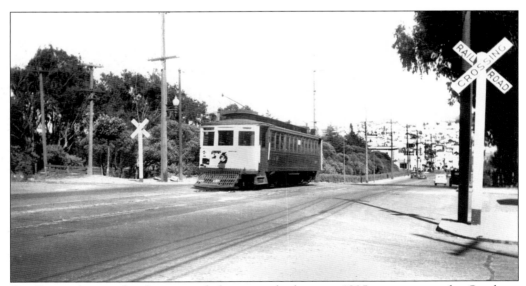

On Ocean Avenue heading toward the zoo, suburban car 1235 crosses over the Southern Pacific's Ocean View Branch in 1940. This peaceful scene is now bustling with noise from Highway 280 and the Muni Metro Yard. (Courtesy Philip Hoffman.)

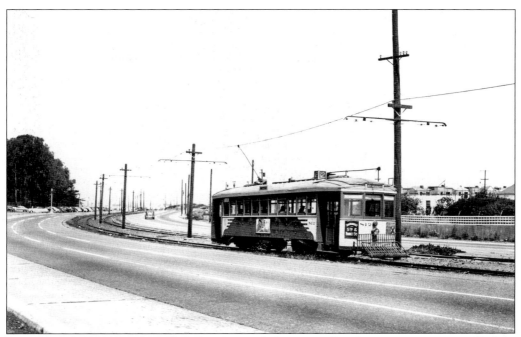

Cars like the 812 were called "cattle cars" because all side seating was installed to handle wartime crowds. Here it speeds along a car-less Sloat Boulevard in 1947. (Courtesy Walter Vielbaum.)

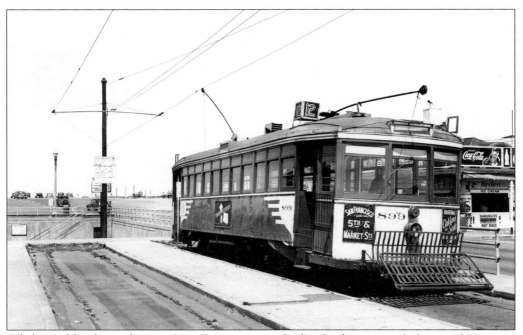

While Oakland is playing San Francisco at Seal's Stadium in 1948, car 899 waits to take zoo patrons home. Muni's "L" Taraval line is one block north. (Courtesy Walter Vielbaum.)

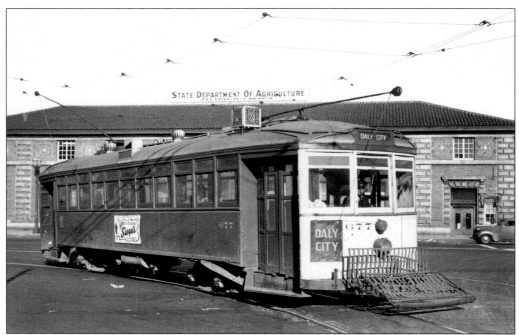

With a brief dash sign showing its destination, No. 14 car 677 turns onto Mission for its seven-mile trek to Daly City in 1947. The agriculture building still stands. (Courtesy Will Whitaker.)

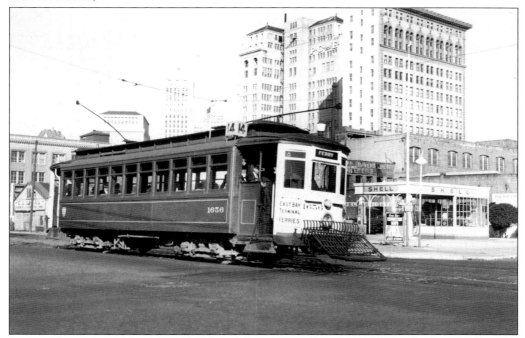

Pictured here is the No. 14 car 1656 on Mission near Steuart in 1939. The Pacific Gas and Electric (PG&E) building dominates the skyline, while nearby, the Shell station is offering free Exposition maps. (Courtesy Tom Gray.)

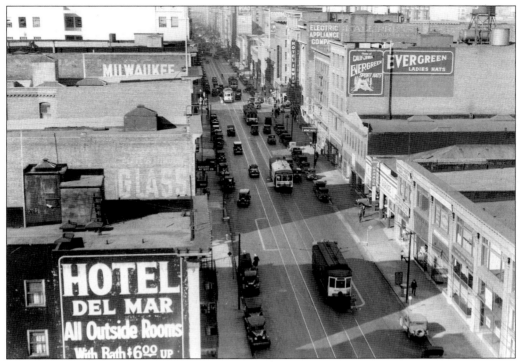

A bird's-eye view shows Mission looking east to Fourth Street and the bay in the mid-930s. The Fifth and Mission Garage now occupies the whole block on the right. (Courtesy Will Whitaker.)

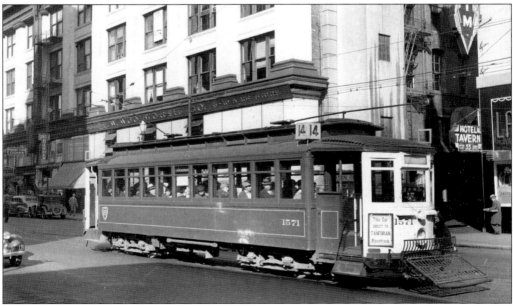

Heading down Fifth to Mission along Woolworth's "Five and Dime" in 1937 is No. 14 car 1571. Because it is racing season, the No. 14 will continue beyond Daly City to the Tanforan Race Track in San Bruno. (Courtesy Walter Vielbaum.)

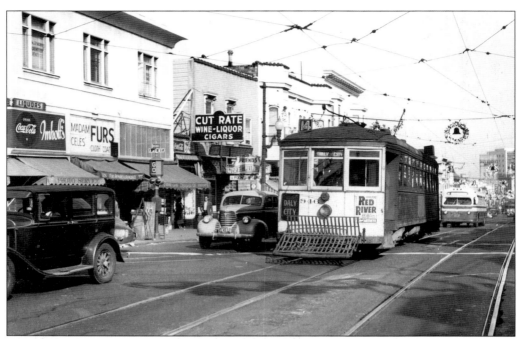

Followed by a peninsula Greyhound bus, No. 14 car 946 is just leaving Twenty-ninth Street on its way to Daly City. The 1948 hit movie *Red River* is playing at the United Artists Theatre. (Courtesy Walter Vielbaum.)

With a swinging load, car 278 passes Highland Avenue. During the war, No. 14 cars would connect at Daly City with one-man cars to San Mateo. They were legal outside San Francisco. (Courtesy Gerald D. Graham.)

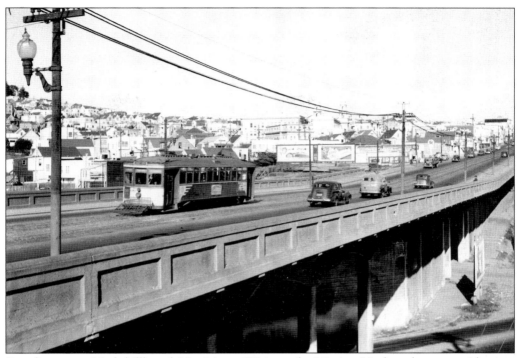

Speeding past a Nash billboard, No. 14 car 686 is on the Mission Viaduct that spans Alemany Boulevard. If no one boarded or alighted, the cars really moved through here. (Courtesy Gerald D. Graham.)

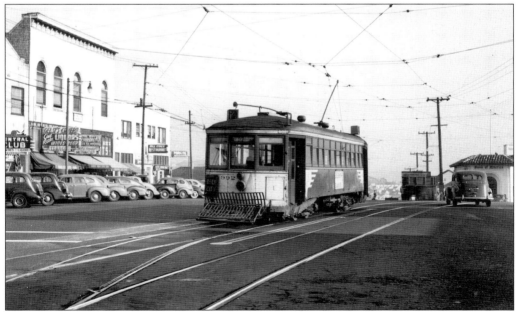

Regular No. 14 service ended here at the "Top of the Hill" in Daly City. Car 992 was the last No. 14 and closed down the line in the wee hours of January 16, 1949. (Courtesy Will Whitaker.)

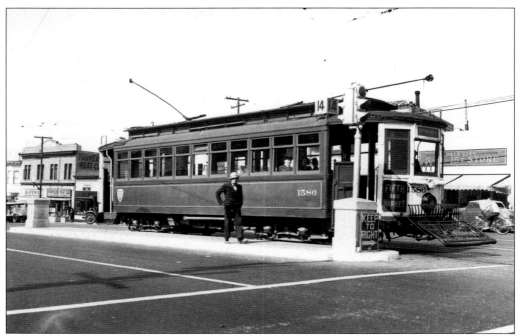

At Daly City, a No. 14 car is ready to depart for Fifth and Market in 1937. Some of the No. 14 cars turn back here after the No. 18 quit in 1935. (Courtesy Walter Vielbaum.)

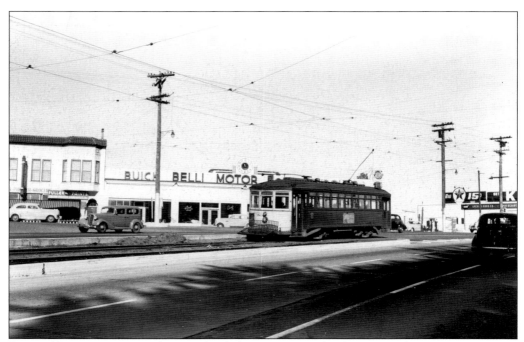

Pictured here at Mission and San Pedro ("the Gateway to the Cemeteries"), No. 14 car 989 was the first MSR car built as a one man in 1933. Here, it heads down the center-strip right of way for Holy Cross Cemetery. (Courtesy Walter Vielbaum.)

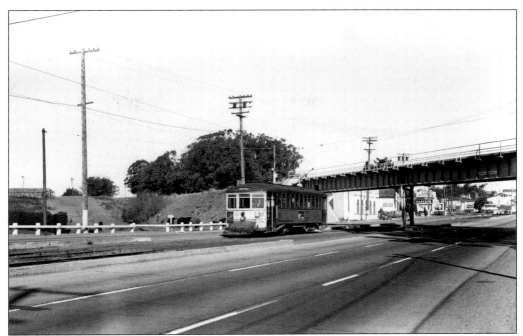

Cemeteries-bound, the No. 14 Car 923, which would soon be re-assigned to the Muni "H" line, passes under the Southern Pacific Ocean View Branch in 1945. (Courtesy Will Whitaker.)

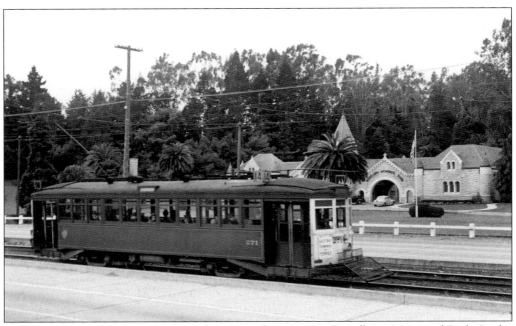

Pictured here in 1943 is Car 271 on the No. 14 line passing Woodlawn Memorial Park. In the late 1930s, the 271 was a one-man car on the No. 19 Polk, No. 36 Folsom, and the No. 25 Bryant lines. (Courtesy Walter Vielbaum.)

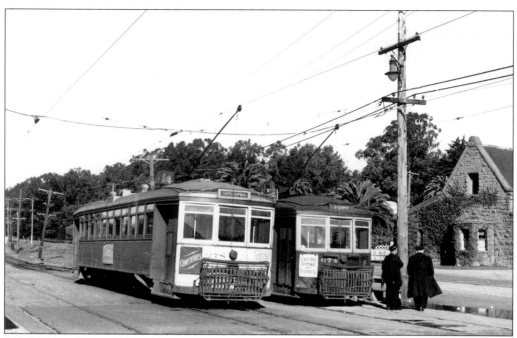

It is Memorial Day 1948 and No. 14 cars 278 and 674 (ex-274) are ready to head back to the city. Car 674 is on the Holy Cross siding. (Courtesy Walter Vielbaum.)

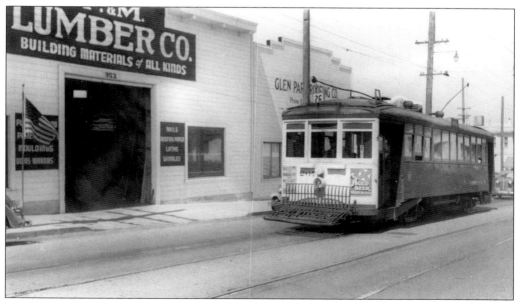

Car 267 is on the wartime No. 26, which is passing the T&M Lumber Company on Ocean near Onondaga. The 1943 No. 26 line left Mission Street at Onondaga and returned to it in Daly City. (Courtesy Will Whitaker.)

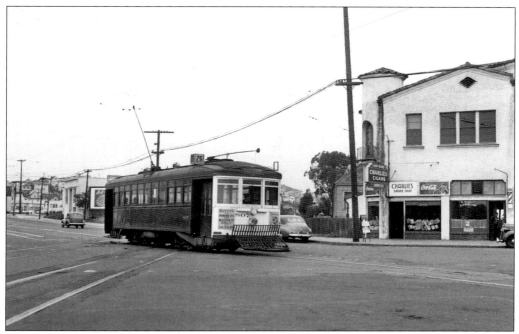

No. 26 car 807 crosses the Southern Pacific Ocean View Branch on San Jose Avenue in 1943. Highway 280 ramps and BART now cover the area. (Courtesy John G. Graham.)

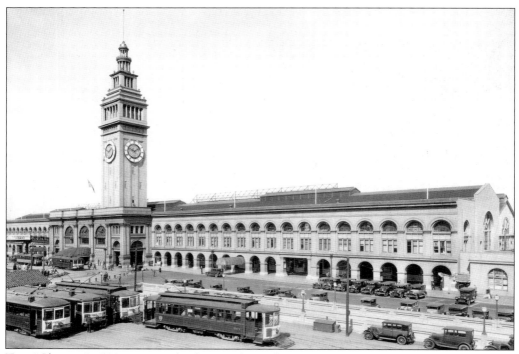

Two "Chicago" 1500s wait on the four-track South of Market Terminal in 1931. Lines 10, 11, 12, 14, 26, 28, 35, and 36 ended here. (Courtesy Walter Vielbaum.)

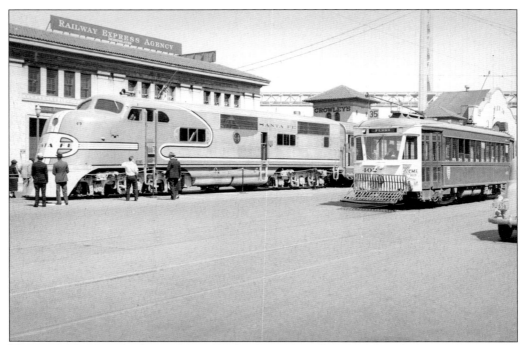

Two streamliners—the latest Santa Fe Art Deco Diesel and Rail Sedan 402—are on the Embarcadero near Pier 16 in 1937. MSR only acquired five of these East St. Louis cars, and the No. 35 was their only line. (Courtesy Richard Schlaich.)

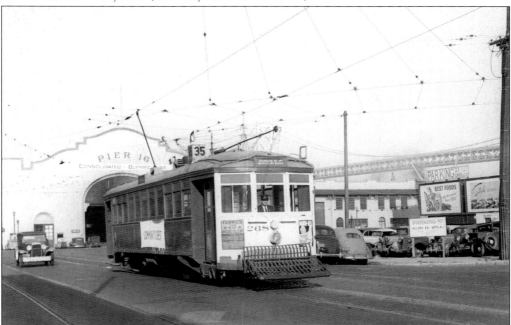

By 1939, the No. 35 was a two-man line and went to bus transportation the next year. Check out the "Havenner" bumper on the 1931 Chevrolet and the 10¢ parking at Howard and Steuart Streets. (Courtesy Al Thoman.)

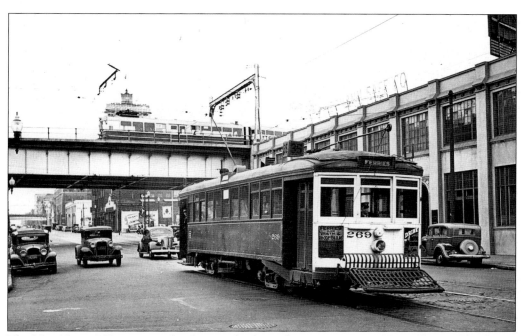

The No. 35 car 269 passes under the new bridge railway structure on Howard near First Street while an infant Key unit is running above. The No. 35 had one more year to run, while the Key trains would have a short life of 19 years. (Courtesy Al Thoman.)

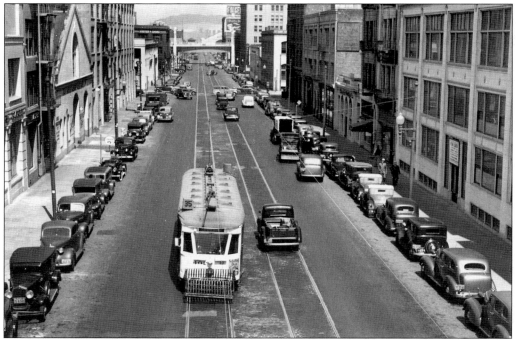

This 1938 photo looks east on Howard between First and Second with Rail Sedan 402 headed for Twenty-fourth Street and Rhode Island. The Key trains will be running in a few months. (Courtesy Will Whitaker.)

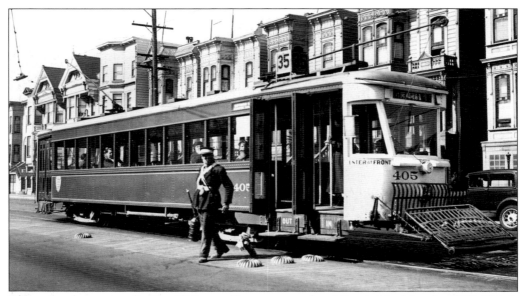

This rail sedan graces the No. 35 line at Twenty-second and South Van Ness in 1937. This is a good illustration of their unusual door arrangement. (Courtesy Will Whitaker.)

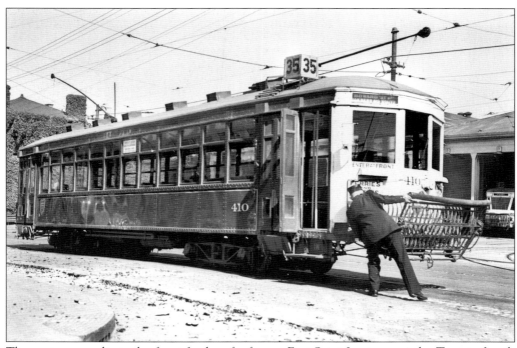

The motorman adjusts the front fender of a former East Saint Louis car at the Twenty-fourth Street and Utah barn in 1937. This ivy-covered structure was converted to house motor coaches in 1940 and was torn down in the 1990s. (Courtesy Will Whitaker.)

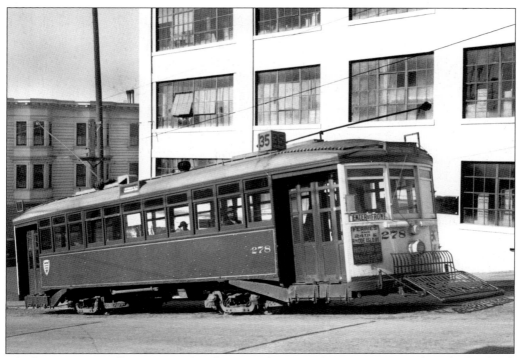

Climbing Potrero Hill on Twenty-fourth Street, this No. 35 is near its terminal at Rhode Island. The No. 35 would be required to go back to two-man operation a year later. This was the steepest grade in MSR's electric system—with the exception of the cable-assisted Fillmore Hill. (Courtesy Will Whitaker.)

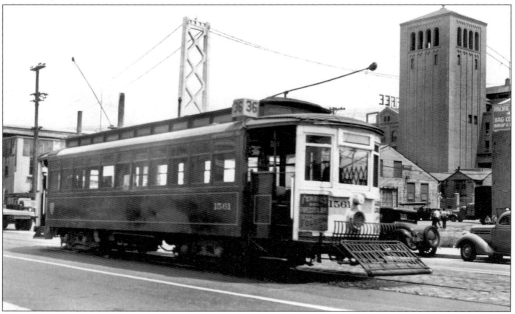

With the Bay Bridge and Hills Bros. Coffee in the background, the No. 36 two-man car 1561 is on Folsom near Steuart in 1939. (Courtesy Will Whitaker.)

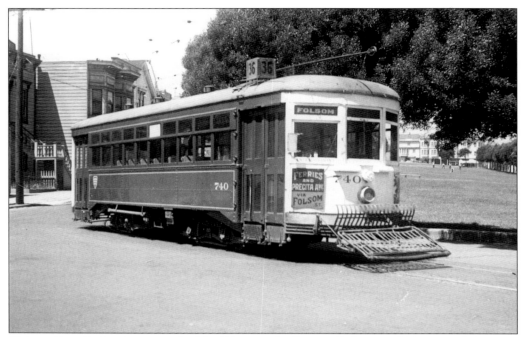

This ex-East St. Louis car on the No. 36 passes by Precita Park near Alabama and Army in 1938. The next year car 740 was rebuilt as a two-man car and later was stored at the Funston site until 1946. (Courtesy Will Whitaker.)

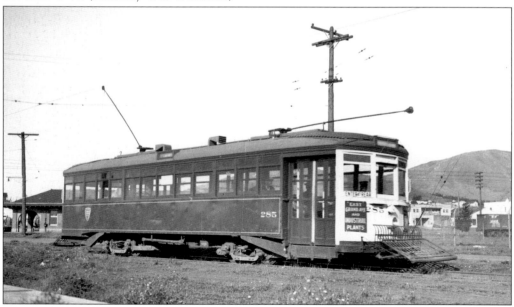

Car 285 just crossed the Southern Pacific main line at the South City Depot and is now on its way on the unnumbered South San Francisco line in 1937. The line served this industrial area as a side-of-the-road operation. Car 285 was unique in having no rear entrance and was later rebuilt into a regular two-man gate car when this line was abandoned. (Courtesy Will Whitaker.)

Three

STARTING POINT MARKET

Line 18) Daly City
Line 20) Ellis
Line 25) San Bruno
Line 27) Bryant
Line 33) Eighteenth Street and Park
Line 40) San Mateo Suburban
Jackson Cable

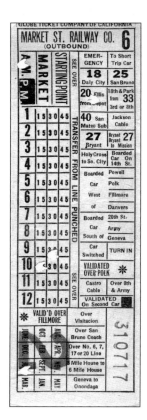

After Memorial Day 1935, the No. 18 Daly City line had a yearly headway (meaning it only ran once a year). It ran on May 30, 1936, and made its next and last run to the cemeteries on May 30, 1937. The No. 20 line reached its greatest extent after the Third Street lines were motorized in May 1941. It started at Golden Gate Park and ran down Page, Divisadero, Ellis, Fourth, and Townsend to the Southern Pacific Depot. During rush hours, it was extended up Third and Kearny to Broadway. Wartime restoration of the No. 16 in 1943 ended the Third-Kearny service. Muni cut the outer end back to Divisadero and Ellis in 1946 and the Muni "F" took over the Fourth Street Southern Pacific Depot service in 1947. Three weeks later, the No. 20 "Ellis Shuttle" made its last run. After 1931, the No. 25 line had a big share of the Seals Stadium business. Even after the Muni "H" extension cut the No. 25 back to Army and Potrero, it ran during two more baseball seasons until 1948. Buses took over the No. 27 in 1940, except for the No. 41 rush hour pull outs from Geneva Barn. When the pull out car reached Twenty-sixth and Mission, it would run over the No. 27 line to Second and Market. The conductor would flip over the dash sign and (voila!) it became an instant No. 41. Pulling into the barn, the procedure would be reversed. With its famous switchback, No. 33 was converted to the West Coast's first trolley coach line in 1935. In 1956, Muni abandoned the Washington–Jackson cable. It was partly reinstated as the Powell–Hyde line in 1957.

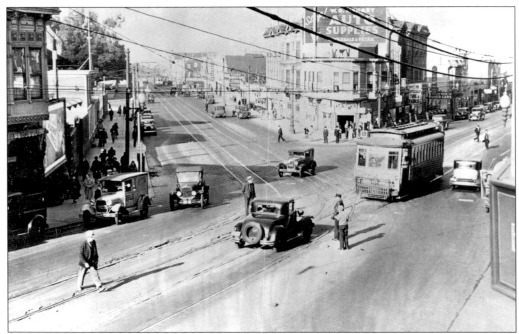

Which street starts at Market, ends at Mission, and is over two miles long? Valencia Street, of course. This is the end of Valencia at Mission. Here is a rare shot of a No. 18 car working its way inbound after the switches for Valencia Street. To the left is the fence of the Twenty-eighth Street car house and a No. 9 car beyond St. Luke's Hospital in the distance. (Courtesy Jack Tillmany.)

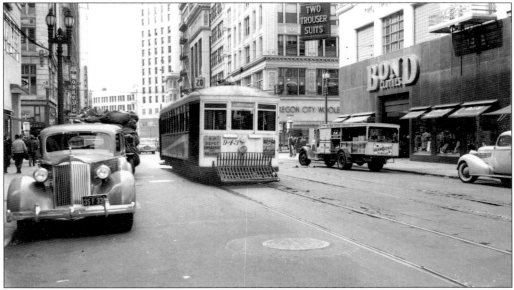

After the Third Street lines were replaced by buses in May of 1941, the No. 20 line was extended during rush hours to Kearny and Broadway to handle the crowds. Car 943 is on Kearny north of Post Street, where men could buy a two-trouser suit at Bond's Clothiers. (Courtesy Philip Hoffman.)

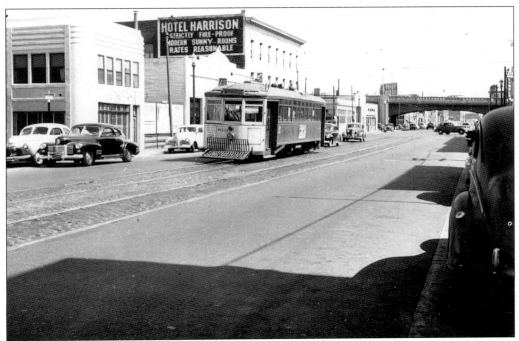

With three 1941 automobiles (Chevrolet, Cadillac, and Plymouth) alongside, No. 20 car 819 is heading north on Fourth Street (north of Harrison) in 1947. In a few weeks, Muni's "F" line would replace the No. 20 on Fourth Street. (Courtesy Richard C. Brown.)

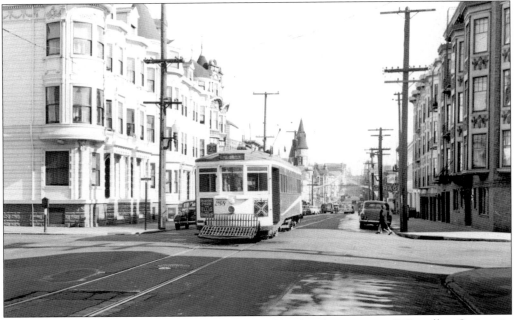

Sporting a fresh Art Deco paint job, No. 20 car 288 is heading west on O'Farrell at Steiner in 1941. Everything in this picture—the buildings, car 288, the No. 20 line, and even part of O'Farrell Street—is gone. (Courtesy Philip Hoffman.)

The one-man No. 20 car 288 is running outbound on Oak Street alongside the Golden Gate Park Panhandle in 1937. The one-man era on the MSR lasted from March 1935 to February 1939. (Courtesy Will Whitaker.)

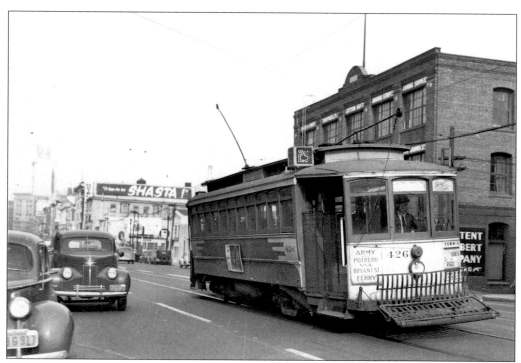

Pictured here is No. 25 car 426 on Sixth Street south of Folsom in 1947. By this time, the Muni "H" line had taken over the part of the No. 25 south of Army Street. (Courtesy Philip Hoffman.)

Pictured at Bayshore and Army Street in 1941, No. 25 car 863 is through for the day and heads toward the Fillmore Barn. Army Street, with its long-gone storage tanks, is to the left. A mass of freeway off-ramps and underpasses now cover the area. (Courtesy Philip Hoffman.)

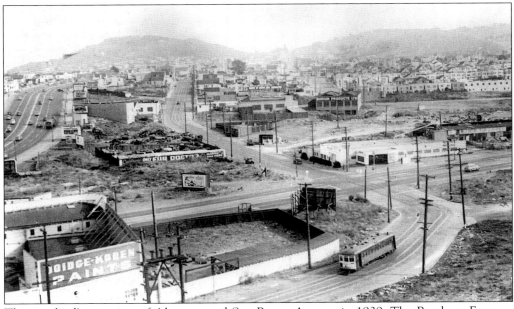

This is a bird's-eye view of Alemany and San Bruno Avenue in 1939. The Bayshore Freeway now cuts through the area left of San Bruno Avenue (seen here with its car tracks). The Muni "H" replaced the No. 25 line on San Bruno Avenue in 1946. (Courtesy Tom Gray.)

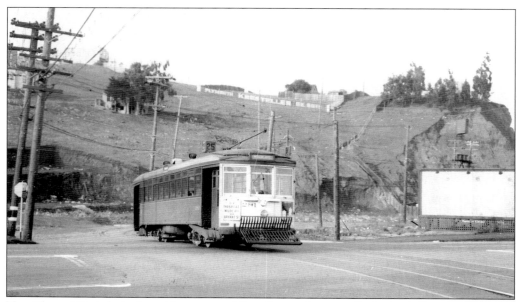

No. 25 car 281 is halted at Alemany and San Bruno Avenue. Both the hill and San Bruno Avenue itself have since been leveled by freeway construction. (Courtesy Tom Gray.)

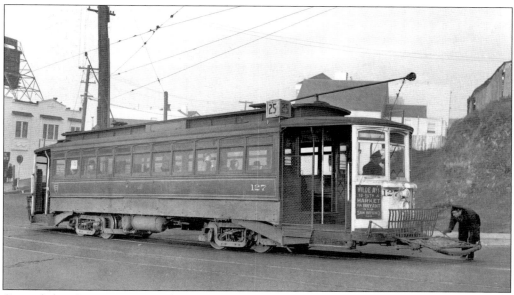

One of the shortest wartime line extensions occurred in 1942 when the No. 25 line was extended half a mile down the crooked outer San Bruno Avenue (over ex-No. 16 tracks) from Wilde Avenue to Arleta where car 127 sits. Only the outbound track was used due to the lack of a crossover at Arleta. As a result, only one car at a time could use the track. (Courtesy Philip Hoffman.)

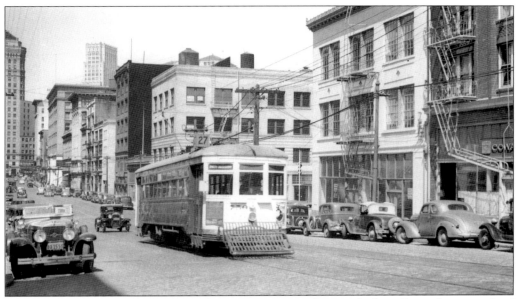

On a warm day in 1939, the top is down on a racy roadster parked on Second just south of Howard. A one-man car from East St. Louis, No. 27 car 750 climbs the remains of Rincon Hill. (Courtesy Tom Gray.)

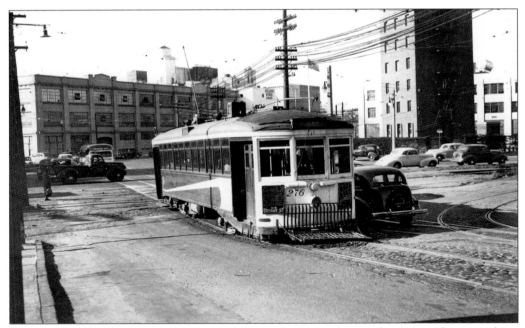

In 1941, No. 27 car 276 has just passed Division Street and crossed a group of spur tracks—now covered by a freeway. The track curving to the right led to the Bryant sub-station, which is now used by the Muni overhead line department. (Courtesy Al Thoman.)

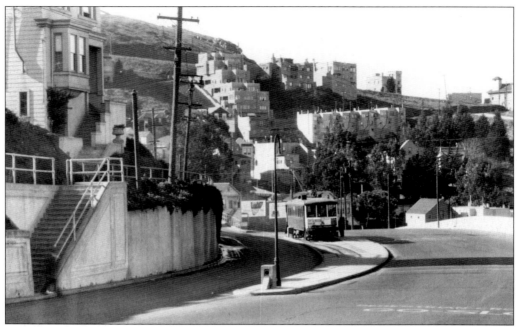

This is the unforgettable No. 33 line switchback in the early 1930s. Car 763 was one of 15 cars with side seating so no one had to ride backwards. No autos mar this scene showing the Clayton Street leg to the left and Upper Market on the right. (Courtesy Philip Hoffman.)

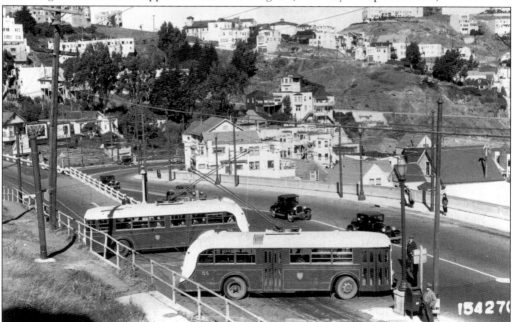

At the site of the switchback, two new trolley coaches inch by each other. The streetcars have been gone a week and the track will be removed shortly. In future years, a lot of MSR (and later Muni) paint will be left on the retaining wall. Since this photo, four generations of newer trolley coaches have made this turn. (Courtesy MSR/Richard Schlaich.)

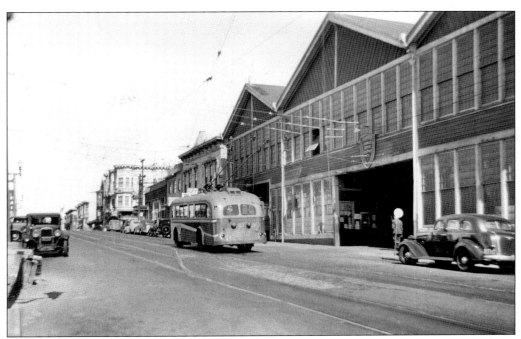

A No. 33 trolley coach with a "Zip" paint job passes the Haight Barn in 1942. Four years later, because of a structural failure of the building, the No. 6, No. 7, and No. 8 streetcars went to McAllister while the No. 33 coaches moved to Potrero—the home of San Francisco's only other trolley bus line—Muni's "R" Howard. (Courtesy Walt Vielbaum.)

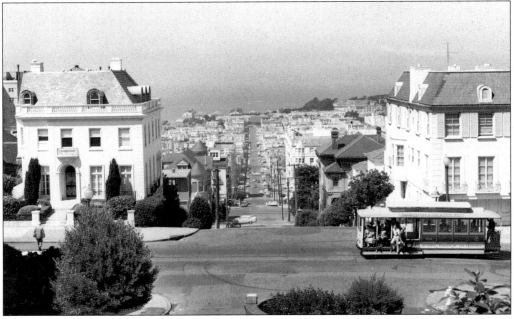

This view shows Octavia Street's end at Fort Mason and the San Francisco Bay beyond. Cable car 521 makes its way through Pacific Heights on the Washington–Jackson line in the mid-1950s. (Courtesy Walt Vielbaum.)

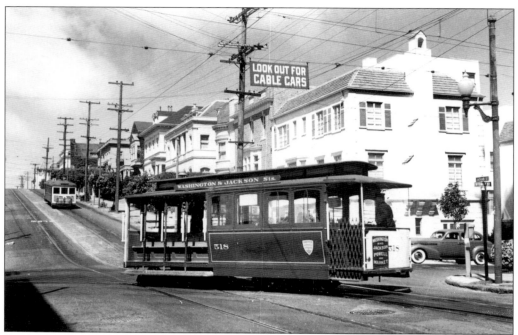

An empty Washington–Jackson cable car turns on Steiner to return downtown in this 1940 view. Before 1906, it would climb the Jackson Street hill, as the No. 3 streetcar is doing here, and go down Presidio Avenue to its terminal at California Street. (Courtesy Will Whitaker.)

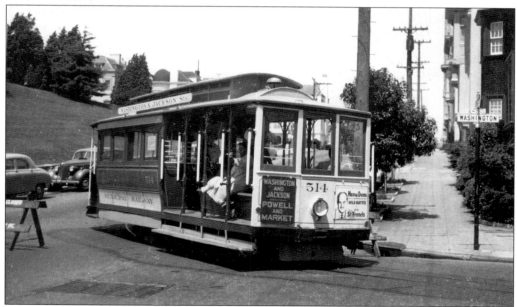

Turning from Steiner onto Washington in 1956, car 514 will stop at Fillmore for its layover. Its Bombay roof is distinguished by the hump under the bell. It will go downtown via Washington and pass the St. Francis Hotel on Powell where Harry Owens and Hilo Hattie are featured. (Courtesy Philip Hoffman.)

Four

OUTER CROSS TOWN LINES

Line 19) Ninth and Polk
Line 22) Fillmore
Line 23) Fillmore and Valencia
Line 24) Mission and Richmond
Fillmore Hill Counterbalance
Post and Leavenworth
Divisadero Extension

Before 1915, the No. 19 was a very heavy crosstown line. It got an added boost when the Panama–Pacific International Exposition opened in the Marina. The fair added three additional temporary lines, which ended in a lot north of Francisco off Polk—the future site of Galileo High School. However, the fair also brought Muni's "H" line, which was not temporary. Running one block west on Van Ness Avenue, the "H" took away a lot of the line's business. Thus in 1939, when one-man cars were outlawed, the No. 19 was the first major car line to get buses. The No. 22 Fillmore was (and still is today) a busy crosstown line that crossed every major Market Street Railway line. In 1948, when the last car ran, the No. 22 was one of the few ex-MSR lines that did not have night and Sunday motor coach service. On August 1, 1948, when the last No. 22 car arrived at the Turk and Fillmore Barn at 1:30 a.m., the inspector said, "There are too many people out there. Make another trip to Sixteenth and Bryant." And it did. The Fillmore Hill Counterbalance was an engineering wonder. It ran for 46 years over two of the steepest hills in the city. When it closed in 1941, buses had to avoid the hills by detouring one block west. The No. 23 and the No. 24 were rambling car lines that were severely curtailed in 1935. The Post and Leavenworth was formerly the Tenth and Montgomery line. It used single truck "dinkies" and closed in 1934. The Divisadero Extension was a real winner—a three-block line with a two-man crew. It stopped in 1932.

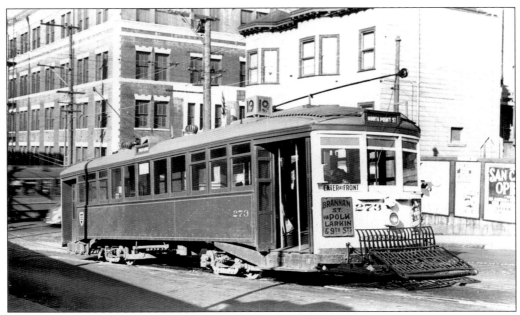

No. 19 one-man car 273 is ready to leave North Point Street and traverse the Polk Street shopping district, along Civic Center to Ninth and Brannan in 1938. The Ghiradelli Chocolate Building still stands, but (alas) the smell of chocolate is no more. (Courtesy Richard Schlaich.)

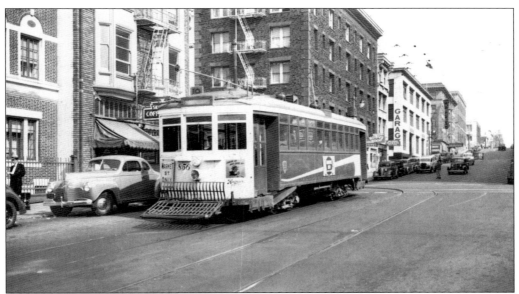

From bus conversion in 1939 to wartime rail restoration in 1942, for some unknown reason, MSR ran one streetcar a day from Polk and Pacific to Larkin and Market. In 1941, this car has just turned from Post onto a two-way Larkin Street. (Courtesy Philip Hoffman.)

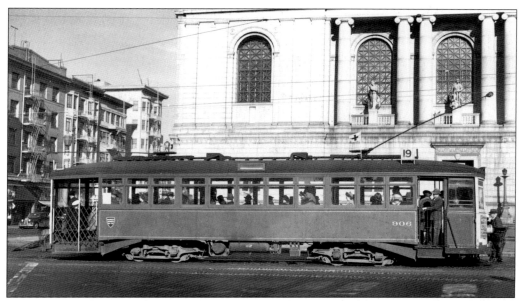

Carrying a good-sized load, No. 19 car 906 boards in front of the main public library on Larkin and McAllister in 1944. The No. 19 was the first streetcar line motorized after the war. Car 906, however, went on to greater things. It was re-motored and, with a new Muni paint job, became a star performer on the No. 22 Fillmore and No. 25 Bryant lines. (Courtesy Will Whitaker.)

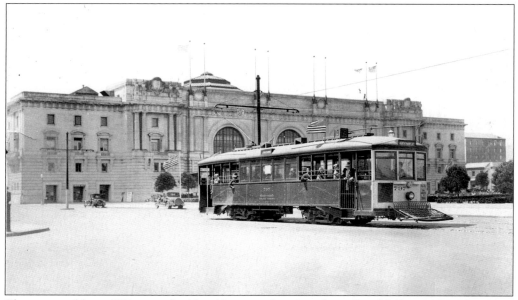

Three-year-old car 797 is on the No. 19 across the plaza from City Hall in 1927. The Civic Auditorium is in the background. Its sister car, the 798, is currently being restored by the Market Street Railway Association to operate in the Muni historic car fleet. (Courtesy John G. Graham.)

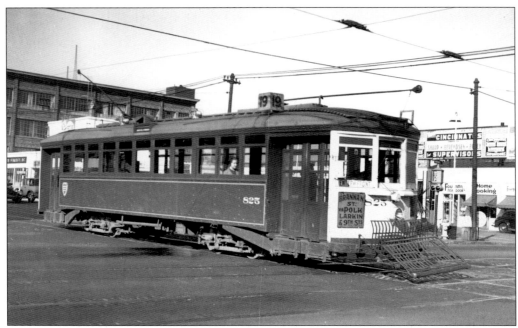

Almost empty, No. 19 car 825 crosses Howard on Ninth Street in 1937. When the No. 19 went to bus transportation in 1939, the Ninth Street track was removed, so the wartime streetcar service restoration was confined to its north of Market stretch. Both Ninth and Howard Streets lost their streetcars in 1939. (Courtesy Will Whitaker.)

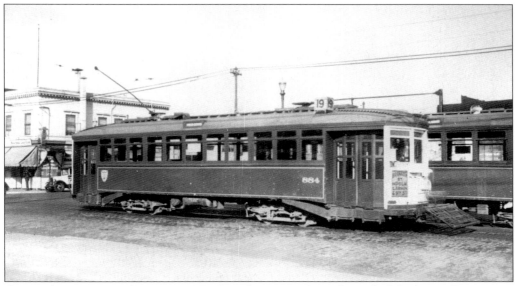

Car 884 has just crossed Bryant on Ninth and is approaching the end of the line at Brannan in 1938. During baseball season in the late 1930s, some No. 19 cars would turn on Bryant and run up to Seals Stadium at Sixteenth Street. (Courtesy Philip Hoffman.)

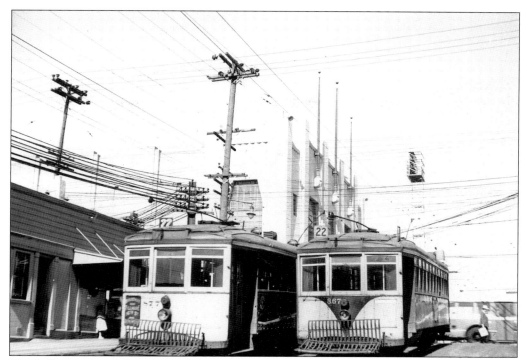

Play ball! It is late July 1948 and the No. 22 cars have one week left to pick up baseball fans at Seals Stadium. A white motor coach crosses Sixteenth Street on Bryant. (Courtesy Al Thoman.)

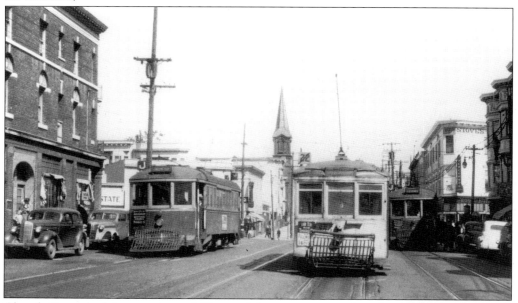

Church Street had four tracks too! Three of them are occupied in this 1941 scene. Because United Railroads and Muni could not reach a track-sharing agreement in 1917 for the new Muni "J" line, Muni laid rails alongside the No. 22 for two blocks on Church from Sixteenth Street to Market. This arrangement lasted until 1946. (Courtesy Tom Gray.)

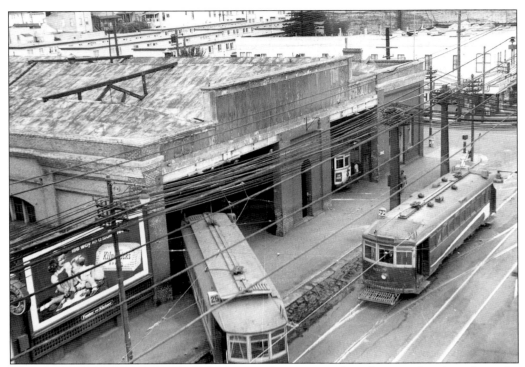

The 1895 Fillmore Barn at Turk Street can be seen in this photograph taken from the powerhouse across the street. No. 25 car 127 has just pulled in, while the crews are changing on No. 22 car 876. The site of the car barn is now the San Francisco Police Department's Northern Station and the powerhouse stands unused. (Courtesy Al Thoman.)

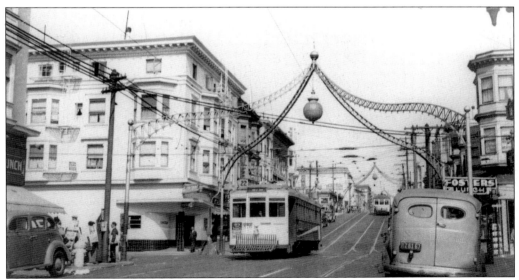

In 1942, No. 22 car 876 crosses one of MSR's busiest transfer points at Sutter and Fillmore. It was the era of wartime "blackouts" and the then-dark Fillmore Street arches, erected in 1907, would soon be dismantled in a scrap drive. (Courtesy Tom Gray.)

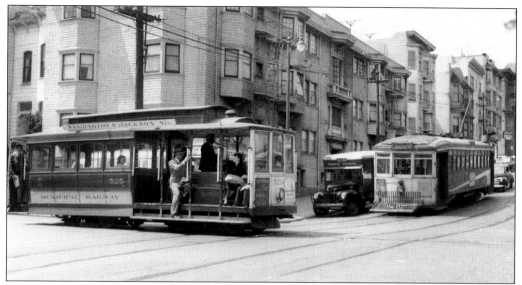

A tourist-free cable car leaves its Fillmore terminal for another downtown trip over the Washington-Jackson line in 1948. Passing the parked Railway Express truck is Third Street–bound No. 22 car 869. (Courtesy Tom Gray.)

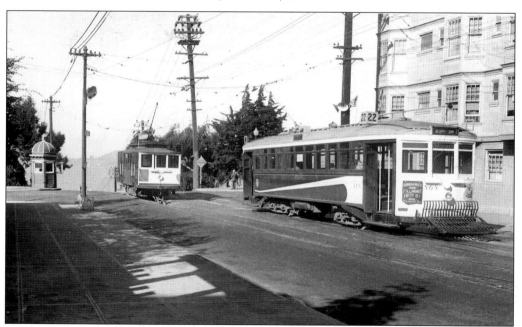

The intersection of Broadway and Fillmore was an important meeting point in 1940 for the Fillmore Hill counterbalance and the No. 22 car line. Between the upper hut on the left and the lower one two blocks below at Green Street, a coordinated counterbalance operation was conducted. In it, both cars were connected to each other via a plow and cable whereby the car going northbound down hill would pull the southbound car uphill. The crew on car 868 has a decision to make—the roll sign says "Twenty-third and Third" while the dash reads "Sixteenth and Bryant." (Courtesy Philip Hoffman.)

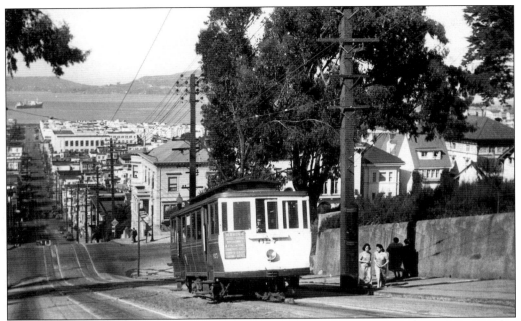

Counterbalance car 627 approaches Vallejo Street while its partner rises above Green in this 1940 view. After the "wishbone" (counterbalance yoke) is disconnected from the "plow" at Green Street, the 627 will run as a normal streetcar down to Marina Boulevard, where a tanker passes offshore. (Courtesy Philip Hoffman.)

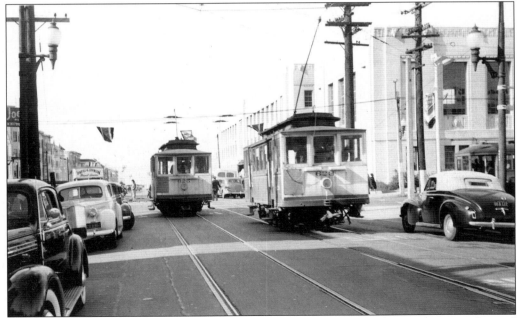

The last day of the Fillmore Hill cars was April 5, 1941. In the background, a new General Motors replacement bus is parked in front of Marina Junior High School, while an overhead banner reads "Welcome new Marina Bus Line." A gray Muni "F" car on Chestnut Street is to the right. (Courtesy Philip Hoffman.)

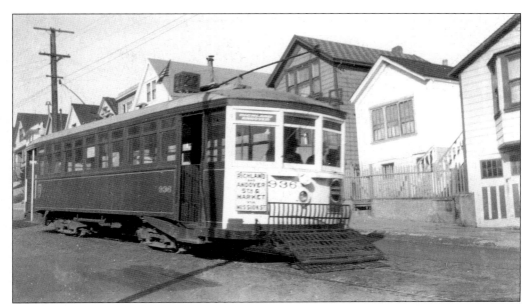

Originally a crosstown line, the No. 23 became the Richland Avenue shuttle in 1935. In 1937, the No. 23 was extended down Mission to Fifth and Market. Here car 936 operates on Richland near Andover Street. (Courtesy Philip Hoffman.)

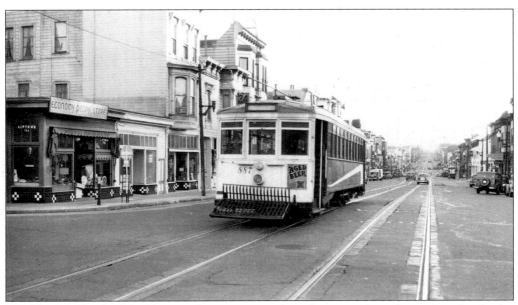

The No. 24, like the No. 23, was a long crosstown line that went through a series of cutbacks. By 1941, the No. 24 was shortened to a 17-block shuttle running on Divisadero between Oak and Sacramento. No. 24 car 887 is at Pine and Divisadero with no destination signs. (Courtesy Philip Hoffman.)

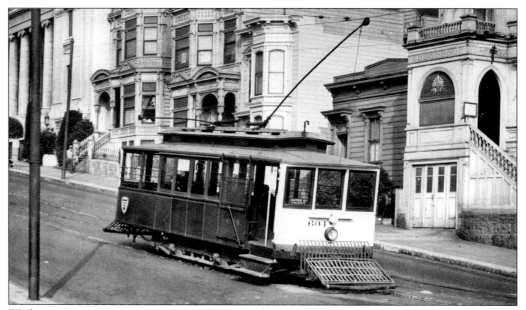

With a two-man crew, one-man car 604 waits for patrons to assist their three-block trek up the Divisadero hill from Sacramento to Jackson. This Divisadero Extension service was the shortest line on the MSR. Crews often ran cars with Eclipse fenders down on both ends. The line closed in 1932 with no replacement. (Courtesy Philip Hoffman.)

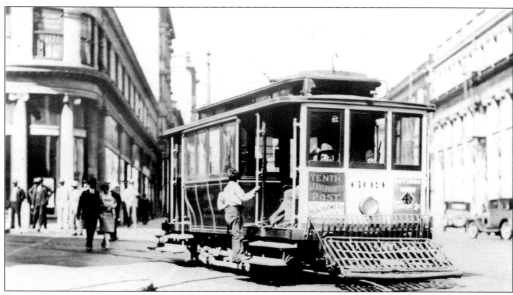

Single-trucker 609 whips around the corner from Washington to Montgomery in 1927—the last year of the Montgomery Street section on the Montgomery and Tenth (unnumbered) line. In 1930, the Tenth Street leg closed. The final routing started at Market and Post Street and ended at Market and Polk. (Courtesy Philip Hoffman.)

Five

SHUTTLE AND SHORT TRIP LINES

Line 30) Army
Visitacion
Castro Cable
Bosworth
Pacific Avenue Cable
Parkside

It is about two miles from Twenty-second to Eighth on Mission. The No. 30 Army Street car took almost six miles to serve these points. How? By running from Mission via Twenty-second Street, South Van Ness, Twenty-sixth, Bryant, Army, Third, Eighteenth Street, Connecticut, Seventeenth, Kansas, Sixteenth, Bryant (again), and Eighth crossing Mission and ending at Market. By rambling all over the industrial area of the city, the No. 30 passed the Union Iron Works, lower Potrero Hill, and Seals Stadium. Around 1931, the wandering line was split—the No. 30 ran from Twenty-second Street and Mission to Third and Army while an unnumbered line started at Eighth and Market and ended at Sixteenth and Bryant. It closed in 1935 and the No. 30 Army line lasted until 1940. To serve the shipyards, a brief wartime restoration line ran in 1943. The standard-gauge Castro Cable was the hilly remnant of the 1883 Market Street Cable line. After 1906, it had its own barn and powerhouse south of Twenty-fourth Street at Castro and Jersey Streets. A single-track jerkwater line ran on Geneva Avenue from Mission to Bayshore Boulevard. The Visitation line closed about the same time the Cow Palace opened in 1941. The Bosworth and Parkside were two unimportant, unnumbered lines that were gone by 1929. When the Polk and Sutter cable lines were electrified in 1906, the Pacific Avenue swells wanted no "ugly wires" on their avenue. This gave the archaic two-car cables a 23-year lease on life. It closed in 1929 with a great celebration and no replacement.

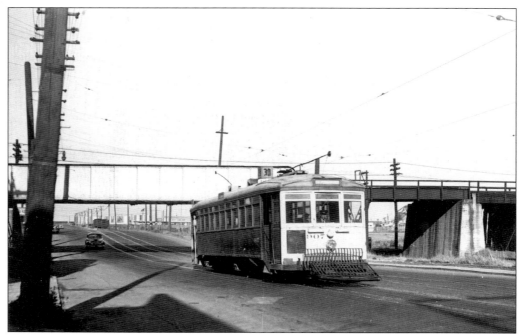

In 1918, to enable more streetcars to directly serve the Union Iron Works and other vital war industries, the United Railroads, with government aid, built the Army Street Extension. It was a one-mile stretch from Third Street to Potrero Avenue. After World War I, the No. 30 line used it until 1940. During a brief era of World War II restoration, car 907 passes under the Southern Pacific at Mississippi Street in 1943. (Courtesy Philip Hoffman.)

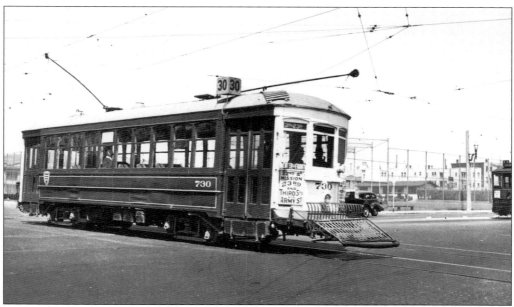

An ex-Williamsport one-man car crosses the Army and Potrero intersection in 1937. A Muni "H" car is ready to leave for Fort Mason on the right. (Courtesy Will Whitaker.)

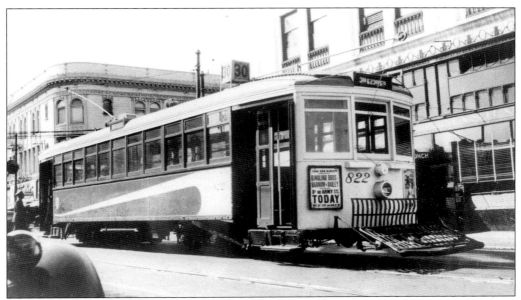

The circus is in town! No. 30 car 822 is ready to leave Twenty-second Street and Mission for the circus at Third and Army in 1940—a few weeks before abandonment. (Courtesy Philip Hoffman.)

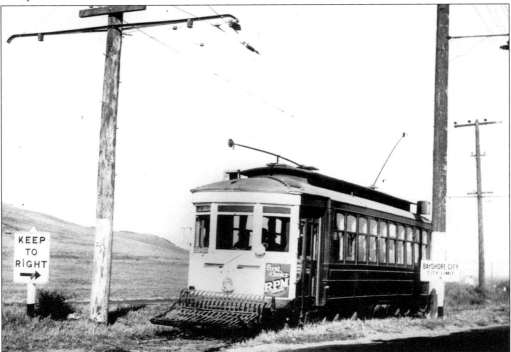

Way out in the wilds of San Mateo County, an ex-Williamsport one-man car 735 speeds through a passing siding. The single-track Visitacion (unnumbered) line connected the outer ends of the Third and Mission lines until 1937. Bayshore City was the unincorporated area between Daly City and San Francisco. (Courtesy Richard Schlaich.)

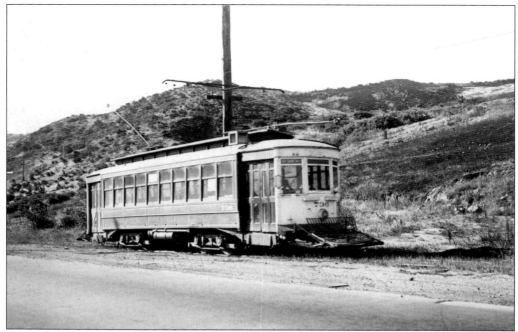

Car 736 is on the Visitacion line, all by itself, running next to Geneva Avenue in 1937. This line was very busy during World War 1, carrying workers from the Mission District to the Southern Pacific Bayshore shops and other heavy industries. (Courtesy Will Whitaker.)

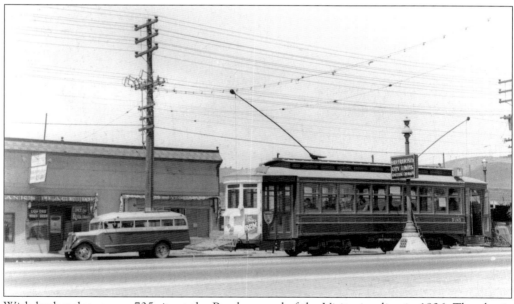

With both poles up, car 735 sits at the Bayshore end of the Visitacion line in 1936. The classic bus is ready to depart for Brisbane. Connections could be made here with the No. 15 and No. 29 Third Street lines. (Courtesy Tom Gray.)

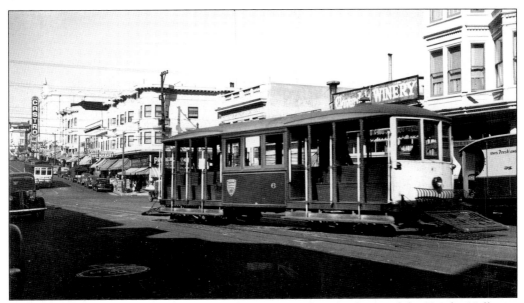

Castro cable 6 has just arrived at its northern terminal in the heart of the Eureka Valley at Castro and Eighteenth Street. A No. 8 car is waiting to carry passengers downtown. In 1938, as today, the Castro Theatre dominates the block. (Courtesy Will Whitaker.)

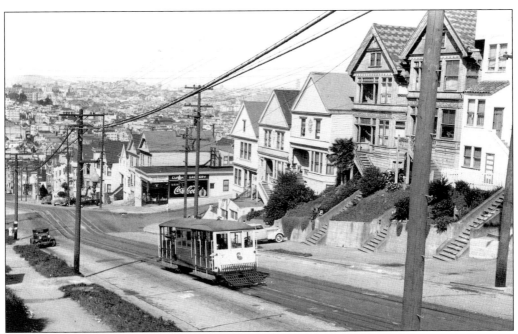

With the city spread out behind it, Castro cable 7 climbs the hill toward Twentieth Street in 1939. The standard-gauge Castro cables were the only ones to have eclipse fenders. (Courtesy Richard Schlaich.)

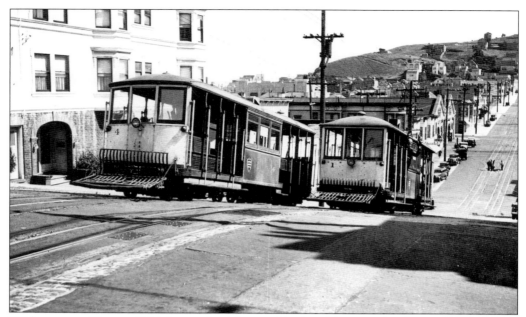

With a vacant Diamond Heights as a backdrop, cables 1 and 4 pass each other north of Twenty-fourth Street. The cable barn and powerhouse is the two-gabled structure on the left in the next block. Later it became the site of the Bell Market (now closed). The No. 11 line on Twenty-fourth Street was the Castro cable's only connection to the MSR shops (Courtesy Philip Hoffman.)

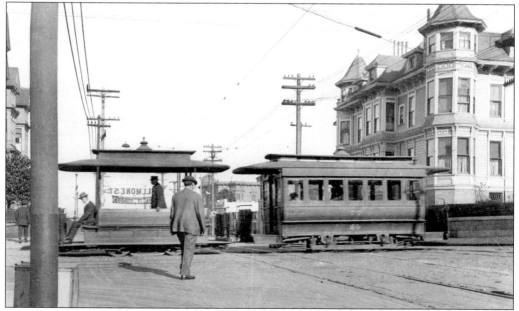

Although this 1915 Pacific Avenue cable photo predates the MSR by six years, the two-car cable train looked the same at the line's closing in 1929. The house on the right at Fillmore became the residence of former mayor Frank Jordan after its top floor was removed. (Courtesy Philip Hoffman.)

Six

INNER CROSS TOWN LINES

Line 15) Kearny and Beach
Line 16) Third Street
Line 28) Harrison
Line 29) Kearny and Broadway
Line 34) Sixth and Sansome
Line 41) Depot to Second and Market
Line 42) First and Fifth
Line 43) Depot
Powell Cable

All these streetcar lines traversed the Third-Kearny corridor. Because it was on the abandonment list, the weak No. 34 was the only line of this group to remain two-man. Most of the line was discontinued in 1936 without replacement, except Sansome Street, which was taken over by the No. 29. The No. 15 was a very busy line because it served the International Settlement (old Barbary Coast), Broadway nightclubs, and North Beach. In the pre-bridge era, the No. 28 was the "gateway" line connecting the transcontinental train ferries to the Southern Pacific Depot. MSR always had its smartest looking cars on this line. Construction of the Bay Bridge in 1935 caused the No. 28 to be rerouted off Rincon Hill—then using the No. 36 line on Folsom to reach the ferry. The Fifth Street leg of the No. 42 line was dropped in 1932, and in 1938, it left First Street to make way for the new East Bay terminal lines. The No. 42 ended up running out Sansome to Chestnut. The No. 16 and No. 29 lines ran all the way out Third, San Bruno Avenue, and Bayshore Boulevard to Visitation Valley. One-man cars were outlawed in 1939, and the city made plans to widen Third Street. Buses took over in May 1941, seven months before Pearl Harbor. Gas rationing soon started and the widened Third Street had few autos on it. Fortunately, the tracks north of Mariposa Street were still in place and the No. 16 line was restored in 1943. The tracks turned off Mariposa and were extended over an electrified Santa Fe spur track to the Union Iron Works. The record-setting Powell–Mason Cable line has had the same route since 1887—except for being shortened 25 yards when the turntable was relocated from the center of Bay Street.

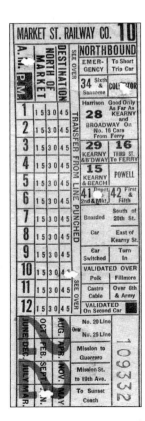

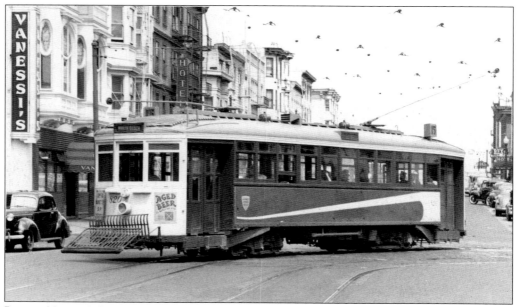

Passing Vanessi's Restaurant in 1940 on its way to North Beach, No. 15 car 820 has just turned onto Broadway from Kearny Street. The Broadway Tunnel was far in the future, so Broadway was not the major traffic artery that it is today. (Courtesy Philip Hoffman.)

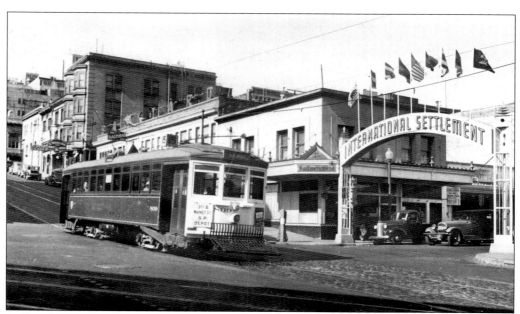

Rolling by the International Settlement at Pacific and Kearny, No. 15 car 809 is about ready to cross Muni's "E" line on Columbus Avenue. (Courtesy Philip Hoffman.)

Crossing Folsom at Third, car 801 has just passed through Skid Row on the No. 15. All these buildings have been replaced by high rises, except the tall telephone company building in the background. (Courtesy Philip Hoffman.)

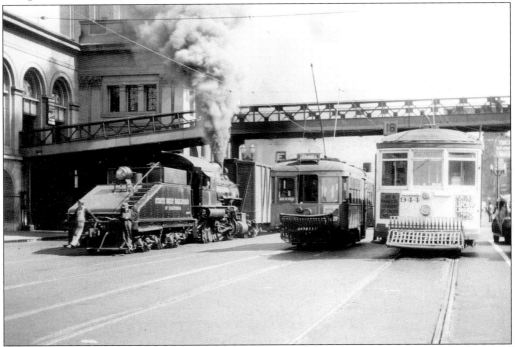

In this photo taken before the "no smoking" era began, a Muni "E" car and No. 16 car 944 await ferry passengers at the North Ferry Terminal stub. Both of the "E" car's trolley poles are almost vertical due to the high overhead—a requirement with railroad activity such as the State Belt steam operation, shown here shoving a cut of box cars alongside the Ferry Building in 1939. (Courtesy John G. Graham.)

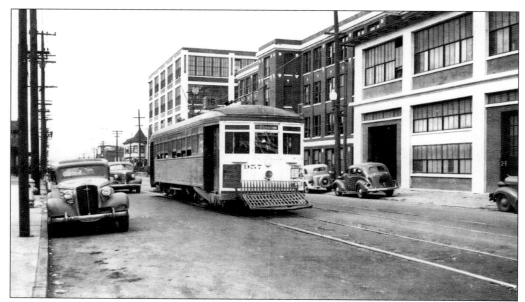

"What goes around comes around." The two-man No. 16 car 957 speeds by the American Can Company factory on Third Street near Twenty-second Street in 1940. Flash forward to 2005 on a wider street, and Muni Light Rail Vehicles will be seen running by the same building. (Courtesy Philip Hoffman.)

"My old Kentucky home." This ramshackle ex-horse car barn was MSR's oldest. When it was built in the 1870s, this stretch of Third Street was called Kentucky. Located near Twenty-third and Third Streets, the No. 22 line used it as a terminal loop. Sticking its nose out in the late 1920s is No. 22 car 1694. In 1941, the Cleveland Wrecking Company razed the barn and took over the property. (Courtesy Philip Hoffman.)

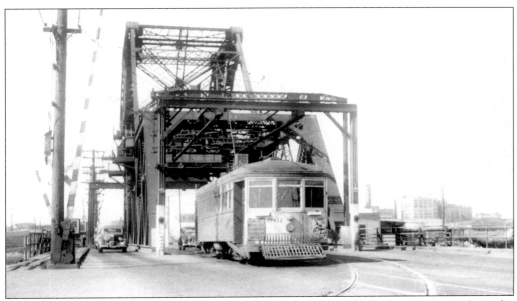

In this view looking north at the Islais Creek Drawbridge in 1940, the curving tack in the foreground is an industrial spur—both Southern Pacific and Santa Fe switchers used the bridge. The new Islais Bridge, built after the streetcars ended, would once again be used by Muni Light Rail vehicles. (Courtesy Tom Gray.)

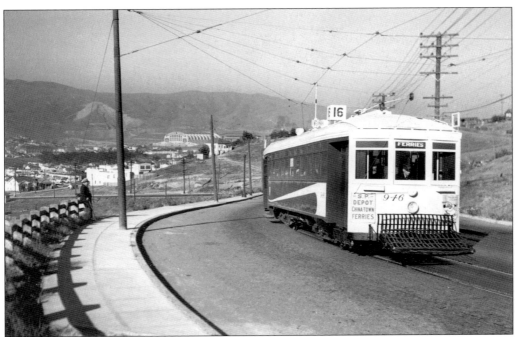

Right out of the paint shop, No. 16 car 946 comes roaring up San Bruno Avenue below Wilde Avenue in 1939. The Cow Palace, the Southern Pacific Bayshore shops, and the hills of San Bruno are in the background. The No. 25 line had a wartime extension down the hill to Arleta using the southbound track both ways. (Courtesy Will Whitaker.)

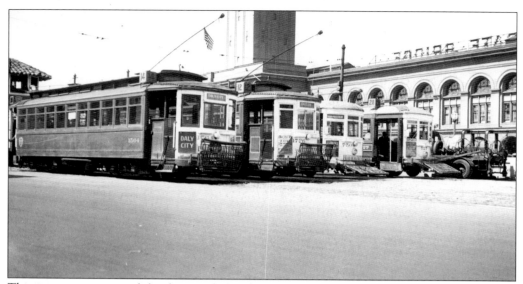

This interesting view of the four-track South Ferry Terminal shows Mission cars on the left with a Folsom and Depot car on the right. At this time (1937), all MSR car lines were one-man except the Market and Mission lines. (Courtesy Will Whitaker.)

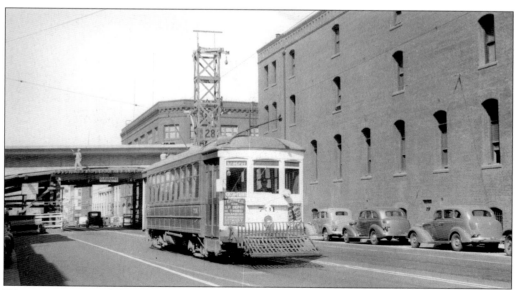

Wearing an out-of-date dash sign showing Harrison Street, No. 28 one-man car 731 is running out Folsom Street to the Southern Pacific Depot. The finishing touches are being applied to the Bridge Railway overpass when this picture was taken in 1938. (Courtesy Tom Gray.)

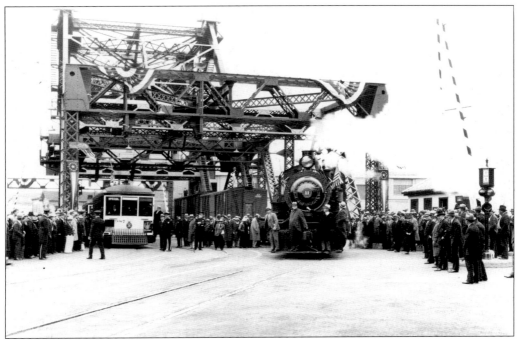

Brand new high-speed car 987 was one of the honored guests at the opening celebration of the new Channel Street Bridge in 1933. Sharing the spotlight is a relatively smokeless State Belt switcher. (Courtesy John G. Graham.)

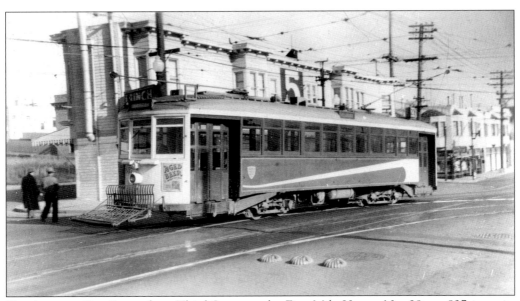

Turning onto San Bruno from Third Street at the Five Mile House, No. 29 car 837 is on its way down San Bruno Avenue and Bayshore to its county line terminal in 1940. (Courtesy Philip Hoffman.)

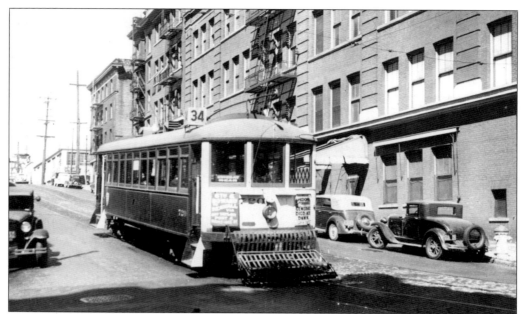

On a spring day in 1936, No. 34 car 720 stops at the corner of Sansome and Pacific Avenue. Gary Cooper is playing in *The General Died at Dawn* at the Paramount. Sansome Street was served by three different lines in as many years during the 1930s—the No. 34 from the onset of numbered routes to 1936, the No. 29 from 1936 to 1938, and the No. 42 from 1938 to 1941. (Courtesy Philip Hoffman.)

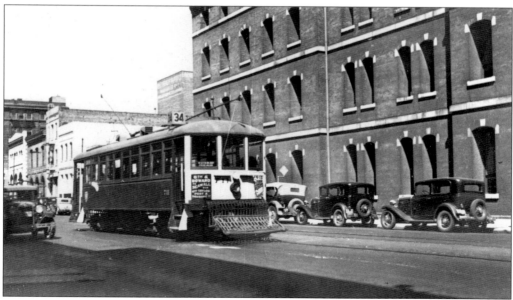

During its last days in early 1936, No. 34 car 711 passes the old Federal Appraiser's Building on Sansome just north of Jackson. It was replaced in the late 1930s by an Art Deco high rise. (Courtesy Philip Hoffman.)

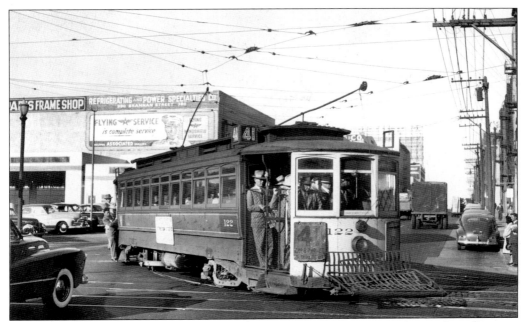

With a swinging load of hat-wearing peninsula commuters, No. 41 car 122 turns from Brannan onto Third Street on its way to the Southern Pacific Depot in 1948. The No. 41 was started in 1927 as a rush-hour commute from Second and Market Streets. In 1949, the No. 41 was replaced by a peak-hour extension of Muni's "F" from the Southern Pacific Depot. (Courtesy Walter Vielbaum.)

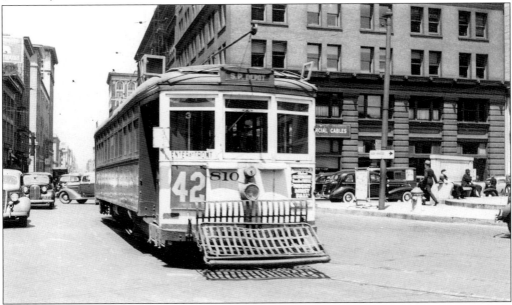

The 1937 No. 42 started at California and ran down Battery Street to Market, where car 810 is shown. From Market, it went down First to Folsom and then to the Southern Pacific Depot. In 1938, it was rerouted off First to make way for the East Bay Terminal Service. The Postal Telegraph Building still stands at 22 Battery. (Courtesy Philip Hoffman.)

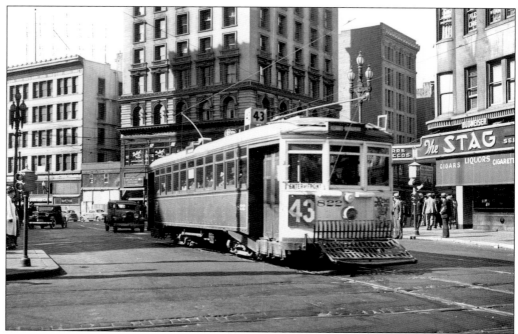

MSR's newest line, No. 43, crosses Market Street from Third to Kearny in this 1937 view. The line opened in 1936 to augment Kearny Street service after the No. 29 was moved over to Sansome to replace the No. 34. The unremodeled Spreckels Building (now Central Tower) is behind car 822. (Courtesy Will Whitaker.)

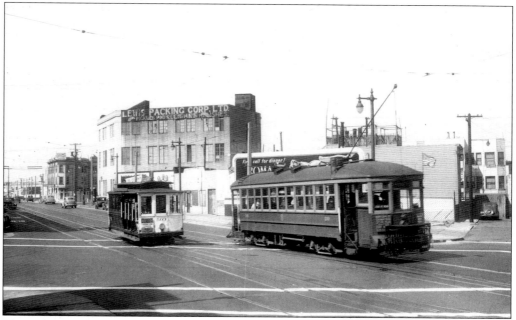

This 1943 picture illustrates another unusual four-track arrangement for two blocks on Columbus Avenue. After the Muni "F" line streetcar service was closed in 1951, the cable car tracks were moved to the curb where they are today. (Courtesy J.E. Tillmany.)

Seven

OVERVIEW TOUR

When Samuel Kahn took over the helm of the Market Street Railway in 1925, one of his goals was to improve the railway's image to San Franciscans. He did this by starting one of the most successful public relations programs in transit history.

—To honor the 75th anniversary of California's statehood, the next 15 new cars to emerge from the Elkton Shops were painted a golden yellow with blue trim.

—Many car barns were painted "Byllesby Green" with a large "SAN FRANCISCO" painted on their roofs to guide lost aviators. The arrow did not point to San Francisco International, but to Crissy Field, the army airfield at the Presidio.

—The Sunday Pass (below left) was introduced in 1927.

—"Jerry," a pie wagon horse that had fallen into a sidewalk elevator shaft, was rescued by "Big Hook" 0130 in front of the Fly Trap Restaurant.

—Business car "San Francisco" became an all white "school car" that carried many happy children on field trips.

—The patented "white front" became a great safety feature.

—All through the Depression, the Elkton Shops kept turning out new streetcars using local employment and materials.

—Major track reconstruction projects were carried out, including Sutter Street, Colma, Bayshore Boulevard, and the 1932 three-mile Balboa Extension.

Muni competed with MSR in many ways. In addition to laying track outside MSR tracks on Market Street, the City banned parasitic jitneys on all streets but two: Mission and Third, which just happened to be MSR's heaviest. The No. 17 line (Haight–Ingleside) suffered three Muni hits: banning the use of Muni's Sunset Tunnel, cutting off its heavy Sunday zoo business in 1937 by widening Nineteenth Avenue, and starting a competing bus on Nineteenth Avenue in 1941. The City also revoked MSR's Howard Street operating permit in 1939 and started a bus line, which served the Mission District for the first time. When fares were raised to 7¢ in 1938, tokens were issued for convenience at five for 35¢. "Streetcar Heaven" candidate 0601 is followed by the latest "Super Twin" bus on Market Street in 1947. The Super Twin was gone by 1970 and 0601 (now 578) is today the pride of Muni's historic fleet.

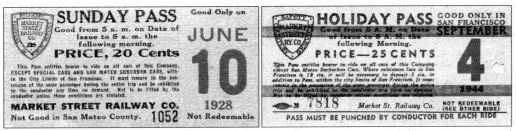

Passes were one of the innovations created during Kahn's management. They were instituted October 30, 1927, and last issued September 4, 1944. (Courtesy Richard Schlaich.)

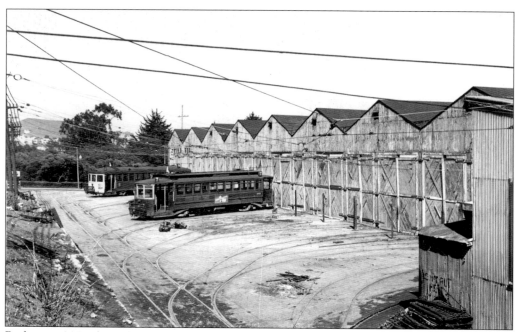

Built in 1907, the Elkton Shops were used for car building and heavy repair. (Courtesy Walt Vielbaum.)

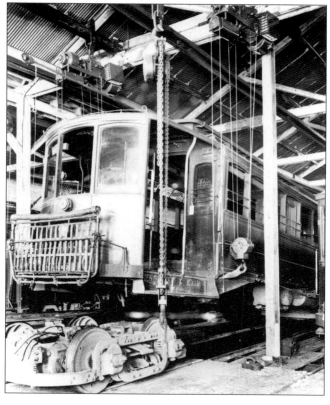

No job was too large for Elkton Shop crews. Car 171 is lifted so that its truck and motors can be serviced. (Courtesy Richard Schlaich.)

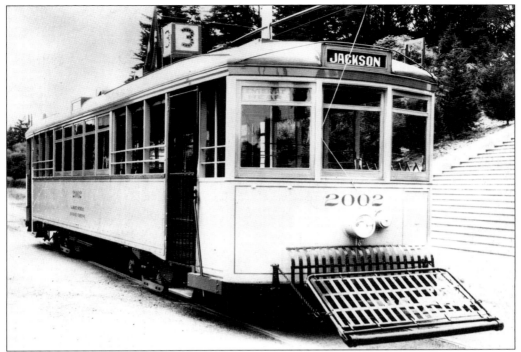

Built in 1925 in time for the 75th anniversary of California statehood, car 2002 was painted in the state colors of gold and blue as one of the modernization efforts of MSR president Mason Starring. Here, it is posed at the foot of the steps at Lincoln Park at Thirty-third and California Streets. (Courtesy MSR/Richard Schlaich.)

This is pride of ownership. A "Balboa High Speed" car built in the company shops bore this sign when proudly introduced to the public in 1932. (Courtesy Walt Vielbaum.)

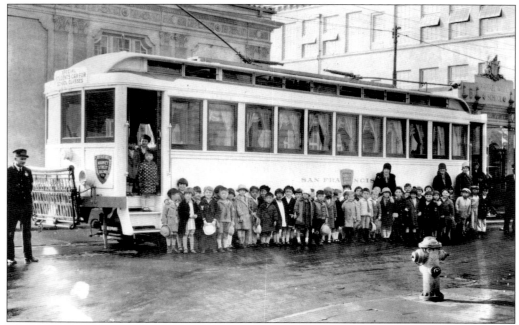

The MSR converted the former excursion car "San Francisco" into a school car to carry students to special events and tours of the company facilities. Above, it is at the Raphael Weill Grammar School on O'Farrell at Buchanan Street in December of 1927 and, below, with MSR employees spreading Christmas cheer at Second and Market Streets. (Courtesy John G. Graham.)

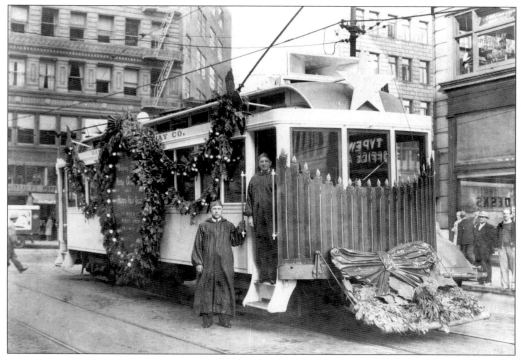

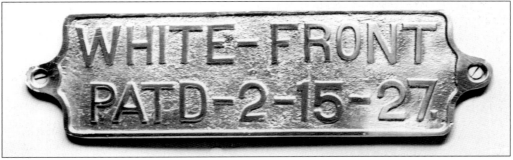

Samuel Kahn received Patent No. 1,617,761 for a "Safety Car" design in 1925. Beginning in 1927, cars were painted white and equipped with two dash lights to increase their visibility. Brass plates like this were cast in the company's foundry at Elkton and installed on the lower right corner of the dash of each car. (Courtesy Walt Vielbaum.)

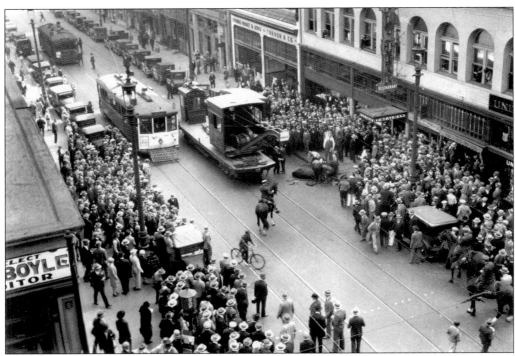

On October 27, 1927, crane car 0130 was employed to lift a horse that fell through the sidewalk into the basement of the Fly Trap Restaurant at 73 Sutter Street (across the street from company headquarters). The sign on the outbound car advertises that the No. 1 and 2 cars can be taken to view the wreck of the freighter *Coos Bay* at Land's End. The 0130 resides today at the Western Railway Museum in Suisun City, California. (Courtesy Richard Schlaich.)

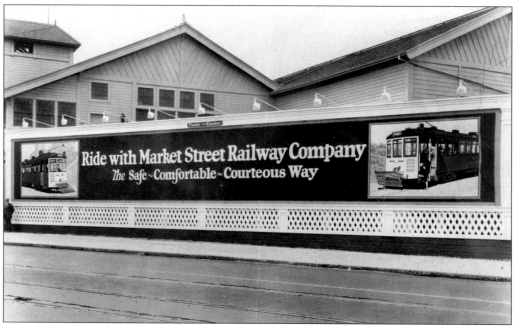

Advertisements were introduced in the late 1920s to encourage ridership. This sign ran along the fence of the Twenty-eighth and Valencia car house in 1930. (Courtesy John G. Graham.)

In October 1931, MSR attempted to lure commuters from automobiles with this ad. At one point, the company offered parking at the Valencia and Market site for 10¢ a day and a free transfer. Note the 1906 quake-damaged smoke stack from the old Valencia and Market cable powerhouse. (Courtesy Walter A. Scott/John G. Graham.)

In 1938, due to regulatory limitations on public utility holdings, Byllesby divested itself of the Market Street Railway to a group including Samuel Kahn and some associates. This necessitated changing the red, white, and green enamel Byllesby shields that adorned the sides of all cars to the simpler white on red shield. (Courtesy MSR/John G. Graham.)

When the fare was raised to 7¢ in 1938, the company had tokens manufactured and they sold five tokens for 35¢ as a convenience to riders. This necessitated changing all fare box mechanisms to count small tokens similar to the one pictured here. (Courtesy Walter Vielbaum.)

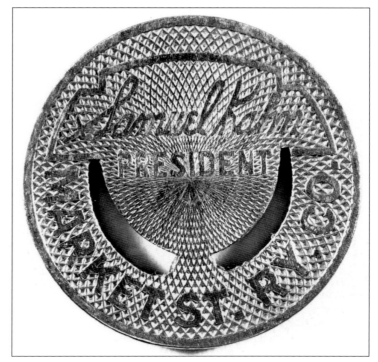

VOTE YES *for*
2 MAN STREET CARS

The Eastern owners of the Market Street Railways are trying to fool the people. They are saying that you ought to vote no on the two-man street car ordinance Thursday.

If you want to keep 1000 men working on the two-man street cars you should vote YES!

HERE'S WHAT'S LEFT OF A ONE-MAN STREET CAR

Seven of your fellow citizens were killed in this accident in Visitacion Valley in 1918. A little girl was killed in Parkside by a one-man car. Another of your neighbors lost both legs in a one-man car accident.

Because of this ghastly record one-man cars were prohibited.

Let's make that prohibition permanent and secure by voting YES on the two-man street car ordinance which would for all time ban the one-man car.

By 1935, every line that did not traverse Market and Mission Streets had been converted to one-man operations. The City proposed a charter amendment to prohibit this cost-cutting practice. When successful, this ordinance had a severe effect on the company's balance sheet and sped the conversion of several lines to motor coach operation. It did not affect the Muni due to their heavy patronage. (Courtesy John G. Graham.)

Wartime personnel shortages prompted this advertisement in September 1943. During the war, women and African-Americans became a significant percentage of "platform" employees. (Courtesy Richard Schlaich.)

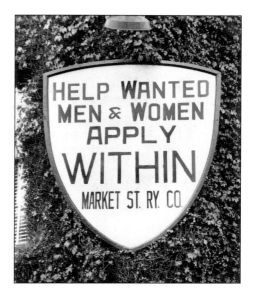

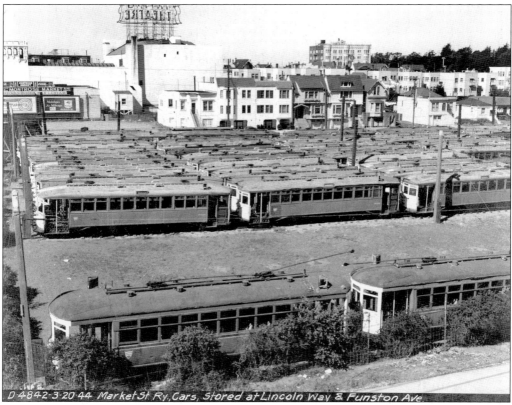

Despite wartime recruiting efforts that included painted car sides encouraging workers to become "streetcar pilots," by early 1944 material and human resource scarcities resulted in many cars being left idle. This photo was taken by the City just months before the consolidation. (Courtesy SFPUC/Richard Schlaich.)

As car lines were abandoned by Muni after the war, surplus cars were burned before being cut up for scrap. Here car 118 is burned at the Mendel Dump near Third Street. (Courtesy Walt Vielbaum.)

Once the pride of the MSR fleet, home-built cars await scrapping. (Courtesy Walt Vielbaum.)

124

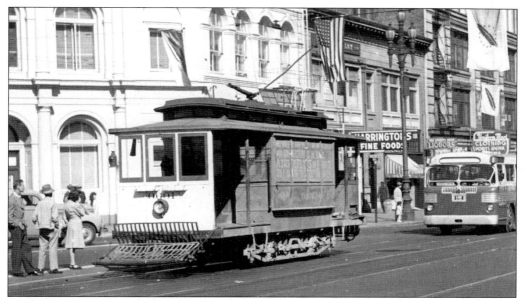

Work car 0601 was an 1895 Holman "dinky" which survived by hauling sand from the company's Twentieth Avenue sand pit to Geneva Division. It was pressed into service in 1947, touring the streets of San Francisco to encourage voters to vote yes on 1-7 . . . "so I can go to streetcar heaven." (Courtesy Richard Schlaich.)

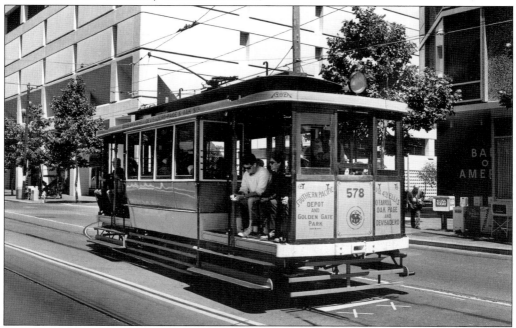

Car 0601 has not yet met St. Peter! It was restored to its original 1895 Market Street Railway livery in celebration of the 50th anniversary of the earthquake and fire in 1956. Here, the restored car operates on Market at Eleventh Street in 1984. The car survives today as part of Muni's Historic Car Fleet maintained by the nonprofit educational Market Street Railway. (Courtesy Walt Vielbaum.)

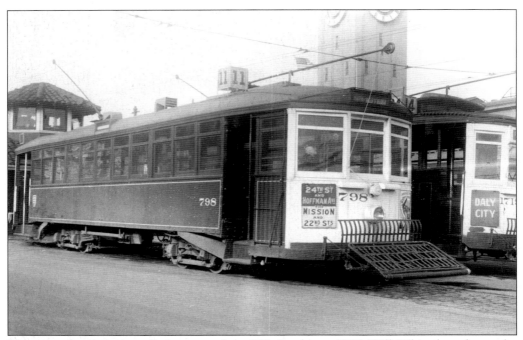

The next three photos tell the saga of car 798. In this *c.* 1938 Will Whittaker photo, the Elkton-built California Comfort Car 798 is in service at the south ferry terminal on the No. 11 line. Car 798 also was a regular on the No. 19 Polk line but never operated on Market Street's "roar of the four" trackage. (Courtesy Will Whittaker/Walt Vielbaum.)

Here, a line of woeful cars awaits their fate at the Mendel Dump off Third Street. The car used as an office and shown end-on to the far right is car 798. (Courtesy Walt Vielbaum.)

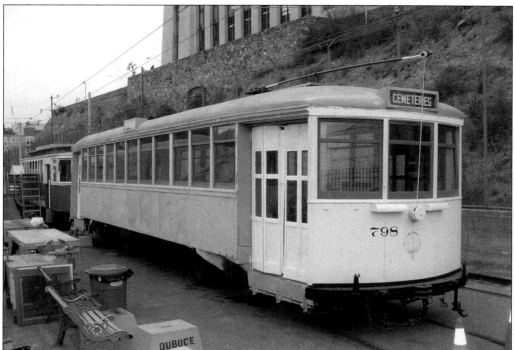

Rescued from a later life in Columbia, California, and having been a Prison Industry project at the Deuel Vocational Institute in Stockton, car 798 is currently being rehabilitated in the Market Street Railway car restoration facility at Duboce and Market Streets. It will join Muni's historic car fleet in the near future and finally get to operate on Market Street as a closed platform car. (Courtesy Rick Laubscher.)

This July 28, 1928 photo harkens back to a time when conductors could exchange pleasantries with passengers and a woman would not think of going downtown without a hat and gloves. (Courtesy S. F. Bulletin/John G. Graham.)

This advertisement outlines the argument put forth by proponents of the bond issue for the City to purchase the Market Street Railway. (Courtesy Walter Vielbaum.)

On the final days of operation in September 1944, Market Street Railway cars carried these window signs. The Company considered itself as having served the city's residents for over 50 years—dating back to the 1893 corporation. On the morning of September 29, 1944, San Franciscans enjoyed a single system with universal transfers and a uniform 7¢ fare. This ushered in the "modern Muni" but foreshadowed the drastic reduction of streetcar service. (Courtesy Robert Townley.)